LEGENDARY LOCALS
OF
THE PINE BARRENS OF NEW JERSEY

KAREN F. RILEY AND ANDREW GIOULIS
FOREWORD BY PETER H. STEMMER

LEGENDARY
LOCALS

Legendary Locals is an imprint of Arcadia Publishing
Charleston, South Carolina

Printed in the United States of America

Library of Congress Control Number: 2013930264

For all general information, please contact Arcadia Publishing:
Telephone 843-853-2070
Fax 843-853-0044
E-mail sales@arcadiapublishing.com
For customer service and orders:
Toll-Free 1-888-313-2665

Visit us on the Internet at www.arcadiapublishing.com

Dedication
Dedicated to all who have worked the land, fought to protect it, educated others, or helped save it from development for future generations to enjoy

On the Front Cover: From left to right:
(Top row) Jim Murphy and the Pine Barons, musicians (Courtesy of photographer Karen F. Riley; see page 66); Steve Eichinger, Piney (Courtesy of Steve Eichinger; see page 51); Walt Champion, sawmill owner (Courtesy of photographer Andrew Gioulis; see page 83); Howard Boyd, naturalist and author (Courtesy of John B. Bryans; see page 75); Ed Bixby, cemetery owner (Courtesy of photographer Andrew Gioulis; see page 81); Betty Jane Crowley, actress (Courtesy of Budd Wilson; see page 78); Elizabeth White, blueberry cultivator (Courtesy of the Burlington County Library; see page 22); Ethel Bert Haines, cranberry grower (Courtesy of the Haines family; see page 28); Francine Still-Hicks, artist (Courtesy of photographer Karen F. Riley; see page 18).

On the Back Cover: From left to right:
Haines family, cranberry growers (Courtesy of Haines family; see page 28); Newt Sterling, hunter and trapper (Courtesy of photographer Andrew Gioulis, see page 58); Ethel Bert Haines, cranberry grower (Courtesy of the Haines family; see page 28).

CONTENTS

FOREWORD

Most of us are aware of the New Jersey Pine Barrens as an environmental and ecological treasure. We have read newspaper articles and viewed a variety of television shows highlighting this vast stretch of undeveloped land, just a stone's throw from the major metropolitan areas of Philadelphia and New York. Its million-plus acres include parts of seven counties and 56 municipalities and cover almost a quarter of New Jersey's land area.

The area's name originated long ago. Encountering a vast area of seemingly unending pine trees and sand, its early settlers saw the landscape as barren in comparison with their homelands. This attitude prevailed for a long time, but we have come to learn that it is not true.

There is an abundance of animal and plant life throughout the Pine Barrens. A total of 39 mammal, 299 bird, 59 reptile and amphibian, 91 fish, and 850 plant species have been found within its boundaries. Many are rare and endangered. It is here that we see the overlap of the farthest range of 109 southern plants and 14 northern plants. Botanists from all over the world visit come to study its unique 12,000-acre stand of "pygmy forest." Its greatest asset, however, cannot be seen. Lying below its surface is a 17-trillion-gallon "lake" of pure water held in layers of sand called aquifers. It is this vast, fragile resource that lies at the center of today's efforts to preserve the Pine Barrens.

Settlement of the Pine Barrens was largely a product of and a reaction to the discovery and exploitation of its varied natural resources and geographic accessibility. The earliest occupants lived on its fringes, where the adjacent bays and river systems provided easy transportation on the first "roadways" in the area. Whaling was practiced off the Atlantic Coast and shipbuilding enterprises sprang up along the rivers. Virgin forests produced the wood for the ships, and sawmills cut the lumber, driven by the abundance of waterpower and wood to meet the demands of nearby Philadelphia and New York.

Workers were drawn to the interior with the discovery of bog iron in the mid-1700s, and furnace towns, including Martha, Batsto, Weymouth, Atsion, and Speedwell, were born. The Pine Barrens' unique natural resources and abundant water supply also fostered the glass and paper industries, ushering in the settlement of additional towns that emerged. Ancillary trades, such as the production of charcoal, were needed to support these industries, and more and more workers arrived to meet the demands. A primitive road network developed to connect the increasing number of settlements and to service the needs of the growing industries. As a result, the Pine Barrens were booming. The diverse mixture of its early inhabitants sowed the seeds that would produce the unique characteristics of the people who would eventually be called Pineys.

The iron and glass industries waned and then largely disappeared by the mid-1800s, followed soon after by the paper industry. Those who did not leave the area when the jobs disappeared turned to the land to provide for their families. Their daily routines largely followed the rhythm of the seasons, with the gathering of sphagnum moss in the spring, the collection of blueberries in the summer, the picking of cranberries in the fall, and the gathering of pinecones and laurel and the cutting of wood in the winter. A spirit of individualism and isolation from the "outside world" produced a unique culture. These are the people we envision when we hear the name Piney. It denotes a certain lifestyle and culture closely connected to the land. Today, the term is more loosely applied to someone who lives in the Pine Barrens; it has become a geographic identifier rather than a cultural description.

The first national awareness of the Piney occurred in 1913 when Elizabeth Kite, a prominent eugenicist, published a fraudulent, misguided study of the New Jersey Pineys that pictured them as feeble-minded, inbred cretins whose reproduction should be controlled by sterilization. The study was eventually debunked; however, its disingenuous portrayal of the Piney remained in people's minds.

Henry Charlton Beck came on the scene in the 1930s and 1940s and reshaped the image of the Piney. He traveled throughout the Pine Barrens as a reporter for the *Camden Courier Post*, speaking with and listening to its inhabitants. His stories peeled back the layers of Elizabeth Kite's untruths and distortions, revealing the unique character and culture of the true Piney. He showed them to be honest, hardworking, unpretentious, God-fearing, and family-oriented people in tune with and dependent upon their environment for their livelihood and survival. Photographer William Augustine would often accompany Beck, providing Beck's rich narrative with a visual dimension. His newspaper columns were later expanded and incorporated into a series of books on the Pine Barrens, including *Jersey Genesis* and *Forgotten Towns of Southern New Jersey*, which continue to inform and fascinate today's readers.

Most public interest in the New Jersey Pine Barrens centered on its colorful occupants until the late 1960s, when John McPhee published his award-winning best seller *The Pine Barrens*. McPhee continued Beck's tradition of historical folklore, endearing the Piney to a new generation, and also expanded the Pine Barrens narrative to focus on the dangers that modern society poses to its fragile environment. Many credit McPhee with the awakening of an environmental movement that led to the joint federal-state efforts to protect the Pine Barrens, the fruit of which we see in the present-day Pinelands National Reserve.

Karen F. Riley is a welcome complement to this trio who fostered our awareness and interest in the people of the Pines. In her latest book, *Legendary Locals of the Pine Barrens of New Jersey*, she combines the empathy and personal insight of Beck with the environmental awareness and sensitivity of McPhee. She adds a variety of compelling photographs, many captured in the current day by photographer Andrew Gioulis in the best tradition of William Augustine.

As I read this book, I found myself on a serendipitous journey, meeting Pineys from the past and present, and realized that the real treasure of the Pine Barrens may not be its natural resources after all, but its precious people. This is a journey that I am sure to take over and over. In the words of an old Piney who snagged a good-sized snapper, "This one's a keeper!"

—Pete Stemmer

ACKNOWLEDGMENTS

I had advanced terminal cancer while working on the majority of this book. That means that there are so many more individuals that need to be acknowledged for their extraordinary efforts than there would be for a book of this undertaking under normal circumstances.

First and foremost is my husband, Bill, with whom I have shared an incredible 32-plus years and raised three beautiful children—Lisa, Laura, and Christopher. Lisa has also blessed us with two sweet granddaughters—Lilyana Elise and Olivia Grace. When I was weak, Bill brought me my meals and took care of the house so I could write; beyond that, he was my moral support and caretaker until the last word was written, and I never would have been able to do this book without his help.

Our acquisitions editor, Erin Vosgien, was upbeat and helpful throughout the project, always working to ensure that the finished product would be something we were proud of and something that matched our vision. She even helped us with our deadline near the end when I was hospitalized and incredibly sick.

All of the people in here were such a joy to interview and I learned so much from them, despite spending over 12 years studying this area. It was an honor to include them, and there while there are many, many other folks who belong here as well; I know that these folks truly represent them and what is best about the Pines, and so this book is for all—included here or forever in our hearts.

Some went above and beyond in helping me locate people or assist in another way. This list includes Mark Demitroff, Elaine and Roy Everett, Patt Martinelli, Steve Eichinger, Bud Wilson, Russ Herr, Terry O'Leary, Paul Schopp, and Pete Stemmer.

My business partner, Andrew Gioulis, participated in most of the interviews and was responsible for all of the imagery and layout in this book, whether behind the lens or making the most of a given photograph. This book would not have been possible without his help, and it is wonderful to watch his passion for this amazing area grow.

Thank you all, for your invaluable contributions that are woven into this book.

And, of course, all of the glory goes to God for blessing us with this opportunity and giving me the strength to complete the book. I pray that He will be honored and glorified through it.

—Karen F. Riley

INTRODUCTION

Moving from the Adirondacks of New York into the most densely populated state in the nation, I was prepared to say goodbye to nature and the great outdoors as I had come to know it. Up until then, my experience of New Jersey had been limited to just a few trips a year to visit family for the holidays. I came to know it as a place existing merely of pavement and parkways, littered with industrial parks and strip malls. As I was just another transplanted tourist to the state, the "Dirty Jersey" stereotype still held strong.

Little did I know that my jaded view of the "Great Garden State" was about to change. All it took was a trip into the Pines.

I was lucky enough to be introduced to the Pine Barrens by my good friend and business partner Karen Riley. At the time, I had just started working with KFR Communications, an award-winning graphic and web design company located in the town of New Egypt. I later discovered that directly across the street from the office, Amelia Earhart once took her first parachute jump. Sadly, the 115-foot tower from which she leapt no longer exists; it was replaced by another ostentatious housing development.

When I first began working with Karen, she was busy on her first book, *Whispers in the Pines*, which covers the environmental aspects of the area through an in-depth exploration of the flora and fauna in Colliers Mills, the northernmost point in the Pines. At the time, Karen needed an illustrator for her book, and I agreed to take on the project. I began to research my subjects, studying the incredible array of plants and animals that exist throughout the Pines. I was surprised to discover the environmental rarities that exist, such as the Pine Barrens tree frog and the bog asphodel.

Karen's second book, *Voices in the Pines*, is made up of true stories from individuals who learned to work and live off the land. Karen's passion for the area was infectious, and after hearing some of these first-person accounts, I found myself wanting to learn more. This book had an even greater impact on me, as I began to see the richness not only in the environment, but in the culture as well. As I accompanied her on many of the interviews, I listened intently to unique characters share their love of the woods and the bay.

I met Bill Wasovwich, to whom many of us were introduced through John McPhee's *The Pine Barrens*, who spends his fall days pulling up sphagnum moss from cedar swamps and, in the winter, gathers pinecones from the Pygmy Plains. There was Newt Sterling, who is considered one of the world's greatest trappers but also runs a successful Internet business selling his own line of handmade snares and lures. And Budd Wilson, who unearthed the stones of the long-forgotten Martha's Furnace, documenting it for generations to come. Through these folks, I learned that this unassuming forest held the secrets of lost industries, ghost towns, and abandoned ruins.

It was incredible to me that all of this was combined in one place—and that much of it was still accessible.

Around the same time that I began to discover the Pines, I enrolled in the MFA graduate program at New Jersey City University and was looking for a topic with some significance to be the focus of my art. The Pine Barrens filled this role in every category and was a subject that needed to be shared with others who may not know about its great importance to our state.

Working as a graphic designer for the past 10 years, I had developed a strong interest in photography as well. Much of my photography began as documentation for my illustrations in Karen's first two books. But, eventually, I began to use the photographic documentation in my graduate work. This would later develop into a nonlinear audio-visual piece devoted to heightening awareness of the Pine Barrens, which was part of my final thesis work after five years of study.

In this fourth book on the Pines, I had the opportunity to further investigate yet another aspect of art through portrait photography. Inspired by the most famous photographer of the Pines, William Augustine, I tried to capture the true sense of each individual. Of all the books I have worked on with Karen, I have found this one to be the most captivating. Through meeting with many of the individuals for interviews and photography shoots, we were able to forge new relationships with the incredible people you will read about in the pages that follow.

It has been a privilege and an honor to work alongside Karen on this book, and my hope is that those who read it will want to step out on an adventure of their own into what the Nature Conservatory has deemed "The Last Great Place."

—Andrew Gioulis

CHAPTER ONE

Early Legends and Visionaries

A visionary is someone who looks at a forest, a new homeland, or the need for a product and then funnels all of his or her energy into making a vision for it a reality. Visionaries are often thought of as crazy for beliefs that seem impossible, but their sheer will and determination amidst the mockery has allowed others to enjoy towns and inventions that once existed only in their imaginations.

Such are the folks presented in this chapter. William Richards was only 14 years old when his father died and he was sent to learn the iron trade; 19 children later, the Richards dynasty ruled the bog iron industry of the Pine Barrens, having full or partial interest in several area furnaces, including Batsto, Atsion, Weymouth, Martha, and Speedwell.

Only two years older than Richards when he got his start was Stanley Switlik, arriving at Ellis Island from Russia. He worked various jobs until, with the help of family and friends, he bought a canvas and leather manufacturing company and turned it into the Switlik Parachute Company. Many military and commercial pilots owe their lives to his products, and the proceeds allowed him to purchase tax liens on property that he later donated to the state to become Colliers Mills Wildlife Refuge, the northernmost jewel of the Pinelands.

Charles Landis borrowed $500 from his mother to purchase approximately 30,000 acres of swampland and forest in southern New Jersey. He was ridiculed for his vision, the local railroad refused to stop in such wilderness, and the government initially refused to grant his request for a post office for his new town. But Landis saw lush vegetation and promise in that wilderness, and Vineland grew to not only become home to thousands, but also to be the birthplace of Welch's grape juice.

Landis was not the only one who saw promise in swampland. Charlie Ashmen, a young preacher from Camden County, was seeking land on which to build a Christian camp. Someone jokingly told Ashmen that there was available swampland in Hammonton for a good price. Ashmen immediately saw potential in the 114-acre abandoned cranberry bog with a stream that drew 100,000 gallons of water per hour from the ground. A mechanic at heart and by trade, he immediately began clearing the land to build roads, three lakes stretching nearly a mile across, teepee villages for campers, and the country's longest noncommercial narrow-gauge railroad.

These are just a handful of the folks readers will meet in this chapter whose courage, determination, and desire helped shape these woods. Readers may question why some individuals were included and others were left out. The goal was to whet the readers' appetite to learn more about this amazing place called the Pine Barrens and realize that even ordinary folks can become extraordinary if they take the time to care and make a difference. The individuals described here are representatives of all those who have come and gone before them—people who had a vision and the will to see it through.

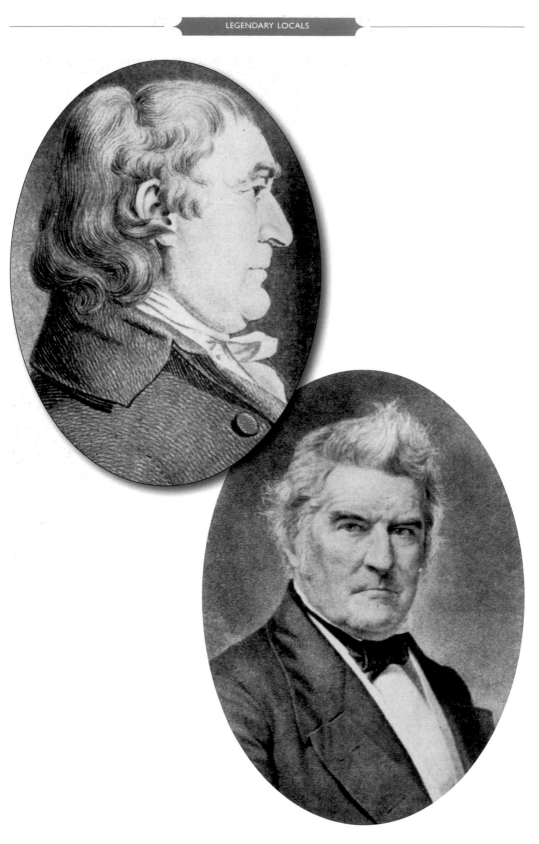

The Richards Dynasty

The Richards family arrived in Philadelphia some time between 1714 and 1718, settling on a 300-acre parcel in the area then known as Amityville. The family consisted of Owen Richards and his wife and four children—James, William, John, and Elizabeth. William had a son he also named William, who was born on September 12, 1738.

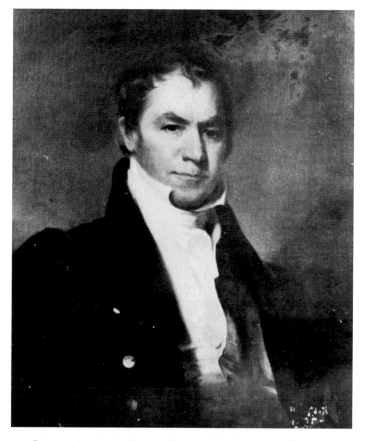

The younger William (opposite page, top) was about 14 years old when his father died and he was sent to Warwick Furnace to learn the iron trade. Warwick was one of the largest iron producers at the time, with refinery and bloomer forges as well as steel and blast furnaces. William married Mary Patrick, the daughter of the works manager, who bore him seven sons and four daughters. After she died, he married Margaret Wood in 1796, who gave him seven more sons and one daughter. On July 1, 1784, he assumed a partial share in Batsto, along with Charles Petit and Joseph Ball. William rebuilt the furnace in 1786 and then bought out his partners.

His sons, especially Samuel (above) and Jesse (opposite page, bottom), worked alongside him, learning the trade. Samuel went on to purchase Atsion and an interest in Weymouth, Martha, and Speedwell furnaces. In 1809, William retired and turned the reins of Batsto over to Jesse to manage. When William died in 1823, the estate was evenly divided among his children and the holdings were put up for auction. Thomas S. Richards, Samuel's son, purchased Batsto and later deeded a half interest to Jesse, who continued to manage it.

With the iron industry flourishing, Batsto continued to prosper until the mid-1800s, when sources of bog iron became depleted and Pennsylvania's ironworks began producing a purer grade of iron ore with anthracite coal, a better smelting agent than charcoal. Jesse and James M. Brookfield went into partnership in 1845 to manufacture glass at New Columbia, now called Nesco, several miles west of Batsto. In May 1846, Jesse opened a second glassworks, this time at Batsto. There, workers made window-glass panes, known as "lights," using the cylinder method.

When Thomas died, Jesse bought his share, securing Batsto with a $13,425 mortgage on the property. When Jesse died in 1854, his eldest son, also named Thomas, took over the management. The mortgage debt, the Panic of 1857, the depression after the Civil War, and frequent repairs took their tolls, however, and the Richards family heirs eventually sold Batsto to Joseph Wharton for $14,000 in 1876.

The property is now owned by the State of New Jersey and administered by the New Jersey Department of Environmental Protection's Division of Parks and Forestry. The mansion, the workers' cottages, and many of the buildings have been preserved and can be toured, along with a museum detailing its history and a general store featuring books and products of the area. (All, courtesy of the Batsto Citizens Committee, Inc.)

Leah Blackman

Leah Mathis was born on January 21, 1817, on a farm in Little Egg Harbor, which today lies within Bass River Township's boundaries, although nothing of her home is still standing. She later married Ezra Blackman and lived on his farm off Mathistown Road in Little Egg Harbor, where a strip mall sits today.

Blackman is remembered mainly for her 1880 text *The History of Little Egg Harbor Township*, which has aided many a local historian and genealogist. She was considered a gifted writer, deftly painting images in the reader's mind with her vivid descriptions of what life was like back then. She wrote poems and a series of works that the Tuckerton Historical Society has compiled in a tome called *Leah Blackman's Old Times and Other Writings*. (Both, courtesy of the Tuckerton Historical Society.)

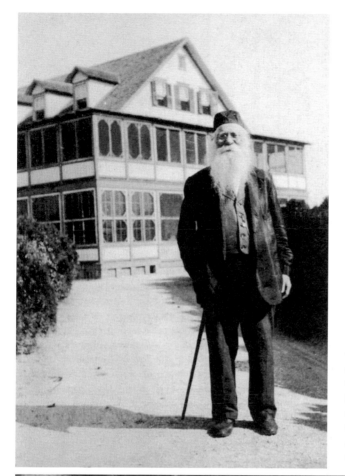

Dr. Charles Smith

Dr. Charles Smith was born in Illinois and educated in Germany. Upon returning to the United States, he first started a practice in Illinois before moving to New York. In 1851, his health deteriorated and he went to stay with a farmer in Patrick's Corner, near New Brunswick, New Jersey.

While fishing in the creek one day, he accidentally allowed water to pour into his boots, which he had kept dry to protect his rheumatic knees. He instantly felt better and declared his rheumatism to be cured.

He became convinced that his accidental water cure restored him, and he felt like a younger man. Smith dubbed the stream the "Fountain of Perpetual Youth," and folks flocked from all over, seeking a similar cure. In 1905, he opened the Neutral Water Health Resort Sanitarium in Egg Harbor City, which featured serpentine concrete troughs filled with creek water. (Both, courtesy of the Egg Harbor City Historical Society.)

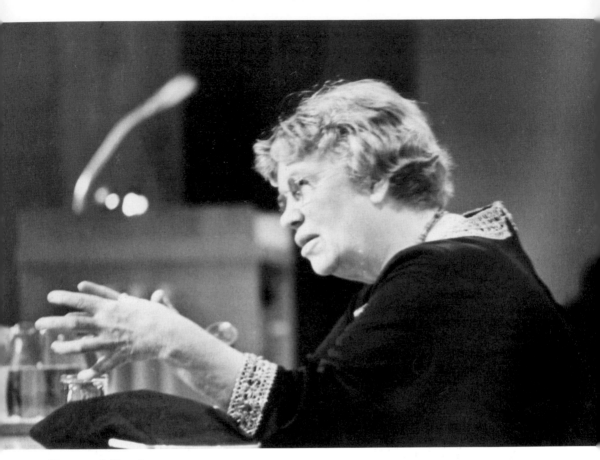

Margaret Mead

Margaret Mead was born in Philadelphia in 1901, the eldest of four children. She graduated from Barnard College and received her PhD from Columbia University in 1929. At Barnard, she first became interested in anthropology, and went on to become one of the most renowned cultural anthropologists of all time. She traveled to Samoa, New Guinea, and Bali to study their cultures, and these journeys wound their way into some of the 44 books and more than 1,000 articles she published in her lifetime.

Mead did her first field research in Hammonton, New Jersey, where she would later reside. She was posthumously awarded the Presidential Medal of Freedom in 1999. One of her most famous quotes should serve as an inspiration for those in the Pine Barrens wanting to make a difference and not feeling powerful enough to do so: "Never doubt that a small group of thoughtful, committed, citizens can change the world. Indeed, it is the only thing that ever has." Mead truly lived her life by those words. (Courtesy of private collection.)

Swarthmore College
Friends Historical Library

Joseph Wharton

Joseph Wharton was born into a devout Quaker family in Philadelphia. Although originally destined for college, he instead began working on a farm at the age of 16, which may have inspired his later interest in growing peanuts and sugar beets. From there, he moved into several businesses and, in 1881, established the world's first collegiate school of business at the University of Pennsylvania, the Wharton School of Finance and Economy.

Around 1873, Wharton began acquiring large tracts of land in the Pine Barrens for the purpose of damming the rivers to provide clean water for Philadelphia, an idea the state legislature quickly opposed. He purchased Batsto in 1876 for $14,000, although he seldom stayed in the mansion.

At the time of his death in 1909, Wharton owned 96,000 acres, or two percent of New Jersey. (Both, courtesy of Batsto Citizens Committee, Inc.)

The Still Family

Levin and Sidney Still were slaves in Maryland. Levin purchased his freedom and moved to New Jersey, with Sidney and their two sons and two daughters escaping to follow him. Sidney was recaptured and then escaped a second time to join Levin, this time only taking their two daughters and changing her name to Charity. The couple went on to have at least 10 more children, the youngest of whom was named William.

William Still (left) became an activist and abolitionist and in 1872 wrote *The Underground Railroad*, which tells of his family history and the nearly 800 slaves he helped escape to freedom. His older brother Dr. James Still became known as the Black Doctor of the Pines and was one of New Jersey's earliest black medical practitioners. Today, the story of the Still family is kept alive by its many descendants, including Francine Still-Hicks (right), who is an artist and gives presentations on the family history. (Left, courtesy of private collection; right, courtesy of photographer Karen F. Riley.)

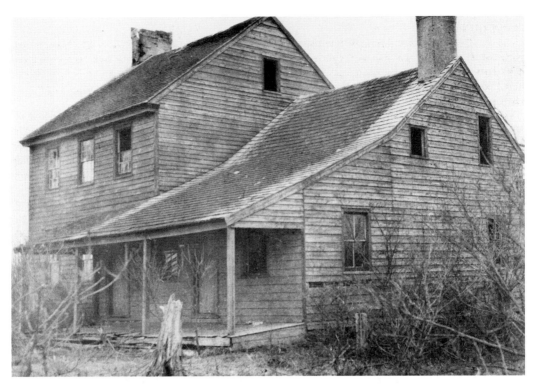

The "Great" John Mathis

John Mathis was the first white settler in the Bass River area and controlled the region economically, politically, and socially for over 50 years, earning him the title "Great."

He was born John Mathews in Wales around 1690, but changed his last name because he felt it was easier to spell and pronounce. He purchased Biddle's Island, in the Bass River area, which is known today as Oak Island. He married and had seven children—Micajah, Job, Sarah, Daniel, Jeremiah, Nehemiah, and Eli.

Biddle's Island was actually a marsh, and Mathis began building causeways, dikes, and bridges to the mainland. In 1729, he purchased 813 acres to the west of Biddle's Island, on which he built another farm and a shipbuilding company, which allowed him to construct vessels, notably Mathis schooners, to trade needed goods in order to flourish.

It is believed that at one time he owned and managed all of the land in present-day Bass River Township from the coast northward to Bridgeport—nearly 5,000 acres. As there were no banks in the area, Mathis was a source of loans, which further increased his assets. He paid for the first tavern built in Tuckerton and helped bankroll the American Revolution. In return for this gesture, the British burned down his house, and he lost most of his fortune as the new American government paid him back in practically worthless Continental currency.

Undaunted, he rebuilt his residence, and it remained of symbol of his greatness until 1973, when it was razed to make room for the Bass River Marina after efforts by the Great John Mathis Society proved fruitless.

In 1760, Mathis left his homestead to his son Job, whose descendants populated Leektown. Job passed the farm on to his son Daniel, who passed it to his son Daniel, and thus the island was known as Dan's Island. Today, it is called Oak Island and is part of the Forsythe Wildlife Refuge.

The landholdings were left to John's sons upon his death, and each received at least 1,000 acres. The parcel from Bellangers Creek to Job's Creek was known locally as Mathistown. Many of his descendants still live around the area and have continued Great John's legacy of community service and involvement. (Courtesy of private collection.)

Charles K. Landis

Born in Philadelphia on March 16, 1833, Charles Landis was practicing law by the age of 19 and became interested in real estate, helping to found the town of Hammonton. He borrowed $500 from his mother with the idea of creating his own utopian community. In his words, he wanted "to found a place which, to the greatest extent, might be the abode of happy, prosperous, and beautiful homes; to first lay it out upon a plan conducive to beauty and convenience, and in order to secure its success, establish therein the best of schools."

Landis used the loan to purchase approximately 30,000 acres of swampland and forest in southern New Jersey. He felt the soil was ideal for agriculture and set out to clear the land and lay out streets in an orderly fashion, driving the first stake into the town's future center on August 8, 1861.

He offered tracts of land for sale with the requirement that a house had to be built on the property within a year of purchase and that at least 2.5 acres of the remaining land had to be cleared and farmed. He also ordered that shade trees be planted along the roads, discouraged fencing, and prohibited the sale of liquor, the latter of which was subject to an annual vote.

He encouraged farmers to purchase 20- and 50-acre tracts at $15 to $20 per acre, which attracted many Italian grape growers, as the land was well suited for the crop. Although many laughed at Landis's vision along the way and he made numerous enemies, the population grew to 8,000 within six years.

On March 19, 1875, Landis walked into the *Vineland Independent*'s office and shot the editor, Uri Carruth, in the back of the head. He was reportedly furious that Carruth had printed an article calling him a "wretch" who was about to have his wife committed to an insane asylum. Carruth lingered for several months before succumbing to his injury. In a touch of irony, Landis was found not guilty by reason of temporary insanity and lived out the rest of his natural life as a free man.

His legacy also includes the founding of Sea Isle City, in Cape May County, and the Landisville section of Atlantic County.

Dr. Thomas Welch

One of the newcomers accepting Landis's offer was Dr. Thomas Welch (left), a dentist who used grapes from local vineyards and pasteurized them to make the world's first "unfermented wine," now known as grape juice. Welch first bottled his product in 1869 to use at his church's communion service. The Welch's Grape Juice Factory in Vineland moved to New York in 1896 when the company was unable to obtain enough quality grapes locally that were free of grape-rot disease. (Courtesy of the Vineland Historical and Antiquarian Society.)

John L. Mason

Another transplant was John Mason of New York City, who invented and patented his now-famous Mason jar with a screw-on lid system, on November 30, 1858. The lid created a sealing mechanism which allowed the jar to be both airtight and watertight. Once the patent was approved on the lid, he contracted for the first jars to be made at the Crowleytown Glass Works. Mason later set up a plant in Vineland where he continued to manufacture the jar. (Courtesy of the Vineland Historical and Antiquarian Society.)

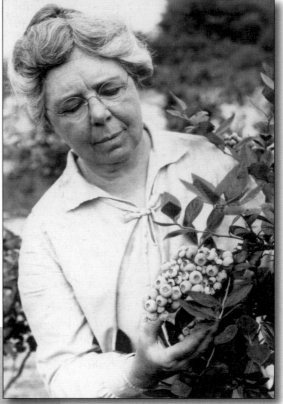

Elizabeth Coleman White
The daughter of cranberry farmers, Elizabeth White worked from 1911 to 1916 with Dr. Frederick V. Coville, a botanist from the US Department of Agriculture, to develop and cultivate a marketable blueberry in Whitesbog. Highbush blueberries grow wild in the Pine Barrens, and Elizabeth drew on the knowledge of the locals to find bushes that she could use in her experiments. (Courtesy of the Burlington County Library.)

Elizabeth Lee
Another Elizabeth, this one with the surname Lee, also started out with cranberries. She owned acres of bogs with her nephew Enoch Bills on what is now called Cranberry Canners Lane in New Egypt. One day around 1912, instead of throwing out some damaged cranberries, she decided to boil them with some sugar instead. She liked the taste and began canning them, thereby becoming a pioneer in the canned cranberry sauce industry. (Courtesy of the New Egypt Historical Society.)

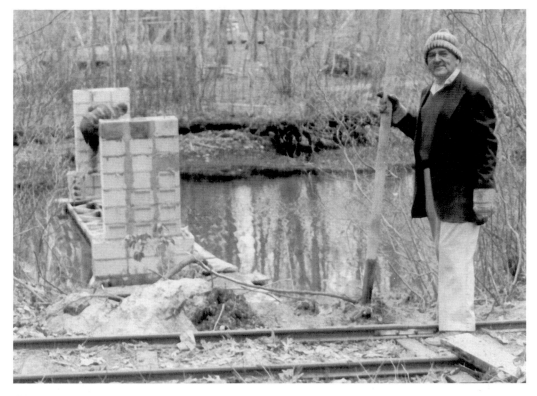

Charlie Ashmen

A truant officer in a new Ford Model A ended eight-year-old Charlie Ashmen's budding career as a valve-grinder in his father's Camden auto repair shop. Although he became a good student, Ashman remained more fascinated by the gears and transmissions than by reading and arithmetic.

That early passion would serve Ashmen well for the rest of his life. After high school, he worked as a fire chief, a tractor-trailer operator, and at other assorted jobs involving wheels and gears. One day, Ashmen headed to Temple University to further his education in industrial engineering. He never made it.

On the way, he stopped at the Bible Institute of Pennsylvania to take a few night courses, thinking it could not hurt an engineer to know Scripture. He walked out, unknowingly, with a full weekday schedule for the ministry. He did not have the courage to go back and correct the mistake, instead saying, "Lord, if that is where I belong, thank you!"

It was at Bible college that Ashmen met Nellie. They headed west on their honeymoon and spent time helping to set up a Christian camp in Colorado. Then they returned to New Jersey and purchased an abandoned 114-acre cranberry swamp they turned into Camp Haluwasa, named for Ashmen's favorite hymn, "Hallelujah! What a Savior." Ashmen's mechanical knowledge paid off, as he got old machines cheap or for free and fixed them up to clear land and dredge the swamp to create three lakes spanning a mile across. Charlie also constructed the country's longest noncommercial narrow-gauge railroad—with a train built from parts costing only $60.

A need for a cafeteria had Ashmen eyeing an old Army barracks with the unaffordable price tag of $1,400. But, a few days later, it was reduced to only $300 when a truck hit the barracks and tore a hole in the side, right where Ashmen was planning to cut in the fireplace. Little by little, the camp took shape from faith, prayers, and ingenuity. For example, instead of offering swimming lessons, he simply put the boys on one side of the lake and the girls on the other—problem solved.

When "Uncle Charlie" passed away in 2008, thousands of letters poured in from all around the world from lives touched by the camp. His legacy lives on in his sons, John and David, and the lives he touched for Christ. (Courtesy of David Ashmen.)

Stanley Switlik

Stanley Switlik (left) was only 16 years old when he arrived on Ellis Island in 1907. He worked at a number of odd jobs until 1920, when he bought the Canvas-Leather Specialty Company with the help of relatives and friends. It later became the Switlik Parachute Company, and, by 1930, it was the country's largest parachute manufacturer.

On June 2, 1935, Amelia Earhart (right) made history by becoming the first public figure to jump from a tower with a parachute. The tower was erected by her husband, George Palmer Putnam, and Switlik. Earhart's willingness to test parachutes helped Switlik's company to later earn an Army-Navy "E" Award in 1942 for its manufacturing effort.

It also provided Switlik with the means to purchase property from Jackson Township that had been taken under as tax liens. He later donated much of it to the state to become Colliers Mills Wildlife Management Area, the northernmost area of the Pinelands. (Above, courtesy of Stanley Switlik; right, courtesy of private collection.)

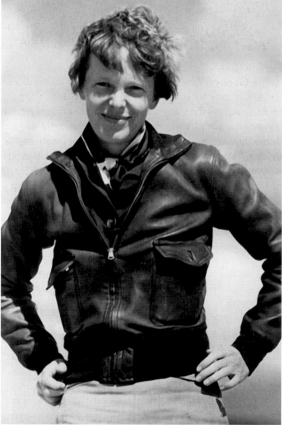

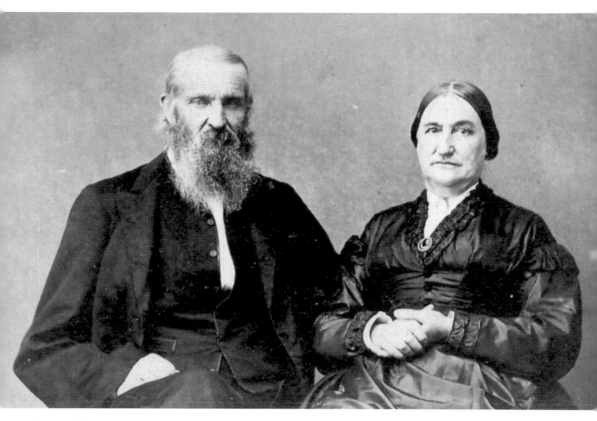

Portia Gage

Portia Gage of Vineland was an organizer of the New Jersey Woman Suffrage Association in 1867. She went to polls with her husband to vote in a municipal election—she was most likely one of the first women in the state to do so—and was turned away politely because her name was not on the registration rolls. She vowed to return the following year. In the *Revolution*, a newspaper published by fellow suffrage members Elizabeth Cady Stanton and Susan B. Anthony, Gage relates her experience, writing, "We have always been told that it was a dangerous place, one where it would not be safe for a woman to make her appearance, that the very atmosphere at the polls was freighted with pollution for women . . . I feel stronger, wiser and better for having come in." (Courtesy of the Vineland Historical and Antiquarian Society.)

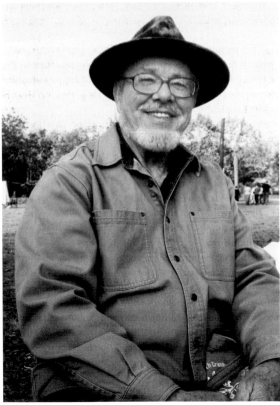

Ted Gordon

Ted Gordon has accomplished what many have only dreamed of doing: in his words, "exploring every sand trail I could drive" in the Pine Barrens. Gordon recorded his journey through photographs, capturing buildings and ruins that no longer exist. He estimates that at least 80 percent of what he shot is gone today.

He started in the 1950s as a teenager and intensified his interest when he got his driver's license. He contributed to major plant studies of endangered species in the Pine Barrens, served four years as a Pinelands commissioner, chaired the Forestry Advisory Committee of the Pinelands Commission for 10 years, was a 2012 inductee into the Pine Barrens Hall of Fame, had a host of speaking engagements, and produced botanical and rare species studies. (Above, courtesy of Ted Gordon; left, courtesy of photographer Karen F. Riley.)

CHAPTER TWO

Stewards of the Land

Some of the strongest opposition to the Pinelands Comprehensive Management Plan (CMP), with its rules and regulations and the Pinelands boundaries, was by folks who felt they best knew how to take care of their land. Sixth- and seventh-generation cranberry farmers resented "outsiders from North Jersey" telling them how best to take care of their land.

However, a peek back in history shows that it was not all about conservation. Many were clear-cutting land at alarming rates, and a vast number of residents favored plans for a large jetport to be built in the environmentally sensitive area known as the Pygmy Plains. Perhaps tired of eking out a meager living or because of the disenchantment of a younger generation, many saw the proposal as an economic boon. But it was not to be.

Today, folks on both sides of the fence are struggling to make peace and work within the new CMP guidelines. For some, like Fred Lesser, German Georgieff, and Mike Magnum, it is about teaching the public to appreciate the natural resources and to learn more about the Pine Barrens so it can continue to be preserved.

For folks like the Haines or Wuillerman families, it is farming within the regulations and learning how to maximize yields with a shrinking amount of overall farmland each year. For the Haines family, the sales of the DeMarco cranberry bogs to the New Jersey Conservation Foundation cost them a working partner and less overall state yields as they struggle to work their bogs more effectively. But, on the flip side, thousands of acres have now been permanently preserved.

Sometimes, stewardship comes about by accident. Betty and Jim Woodford's summer vacation with friends in a lakeside cabin caused them to change direction and purchase land in Medford. This initially led them to become certified bird banders and ultimately to them owning a rehabilitation facility. Their daughter Jeanne has continued their vision by permanently committing the land to preservation, ensuring that no developer will ever fell trees or pour concrete on this land.

Both Hope and Cavit Buyukmihci and Sarah Summerville also blindly fell into their chosen paths. For Hope, it was the alarming question her son asked her: "What is a bluebird?" that made her weather a difficult lifestyle in order to teach her children about nature. Summerville was not motivated by a child, but instead by the stranglehold of corporate life, which made her soul yearn for freedom. When she drove down the rutted, rural dirt trail in the middle of nowhere, something spoke to her and she knew she was home. A baby beaver sealed the deal.

Whatever roads they traveled to get to their destinations, these folks have made peace with the land and the law and are working hard to protect and uphold both. They realize that education is the key to the public's continued desire to protect these lands and that it falls to them to educate those folks about why this place has a special spot in their hearts.

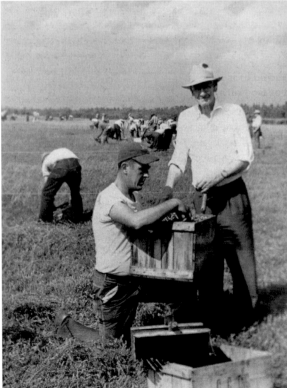

The Haines Family

The Haines family is the country's largest producer of cranberries based on barrels per acre. Their record year produced 327,000 barrels harvested from 1,300 acres. Holly Haines, the youngest daughter of the late Bill Haines Sr., has worked for the farm since 1986 and is the fourth generation to tend the farm. Last year, she retired from her office role to run the Haines Family Foundation, started in 1995 to honor her late mother, Sara, who passed away in 1990 and had always been very active in the educational community. The foundation started with a scholarship at Burlington County College for a single mother, and, when Bill Haines Sr. passed away and left a portion of his estate to the foundation, Holly was able to better focus on working with lower-income families to better their lives through education, housing, and health care. A little over $1.7 million has been donated to date. (Both, courtesy of Haines family.)

Ed Wuillermin Jr.

As small-scale farmers, Ed Wuillermin and his family face unique challenges. An increasing one comes from the regulations that a larger commercial farm can absorb. For instance, Wuillermin has to choose between filling out forms or dealing with something necessary to raise a better crop. Marketing poses another problem, as considerable consolidation is currently taking place; with smaller chains being absorbed and the market becoming more competitive, the producer has less variety without going through larger entities.

These changes may be seamless to the consumer. If one wants a particular product, he or she no longer has to wait for it to be in season. For example, blueberries are sold in winter because they have been obtained from other countries. Consumers may care about quality, but they seldom consider location. Wuillermin fears that, like Joni Mitchell sings in "Big Yellow Taxi," "You don't know what you've got 'til it's gone," and that people in this country are going to wake up too late and realize that they are losing steadily to food being produced overseas.

This marketing shift has impacted the vegetables his family grows on the farm. The crops they currently raise are peas, summer squash, yellow squash, zucchini, cucumbers, bell peppers, eggplant, sweet corn, and Cubanelles. At one time, they raised processing tomatoes for the Campbell Soup Company. One of their current clients is Wegman's, through a local broker, and most of their produce ends up in chain stores, the food-service industry, and restaurants.

The fourth-generation farm is one of the last existing vegetable truck farms in Hammonton, as others have switched over to blueberries, making Hammonton known as the "Blueberry Capital of the World." His great-grandfather started the farm, and Wuillermin runs it today with his brother and his two nephews.

Wuillermin also served on the Pinelands Commission for six or more years, representing Atlantic County and agrarian interests. His view of the Pinelands is that there are resources, such as the cranberry industry and the indigenous agriculture industry, "that are as important as all the other resources in the Pinelands that are worth preserving and have been coexistent with the ecological resources that we have been trying to preserve and are not mutually exclusive. Sometimes nature doesn't give us zero sum choices." (Courtesy of photographer Liz Wuillermin.)

29

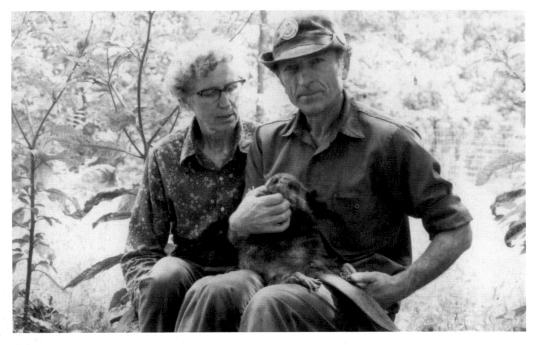

Hope Buyukmihci

When Hope Buyukmihci's son asked her what a bluebird was, she was devastated. She then convinced her husband, Cavit, to purchase an 85-acre tract in Buena Vista in 1961. They decided to dedicate the land to habit preservation so that native wildlife could thrive. They cleared trails and gave tours. Hope wrote three books, photographed wildlife, and used the proceeds to purchase additional acreage.

An orphaned baby beaver they named Chopper became their first rehabilitation. For the first two years of his life, he slept in the Buyukmihcis' cabin and traveled to a nearby pond through a tunnel system they built until he was released back into the wild. Known as the Beaver Lady, Hope continued splitting firewood and tending the property into her 80s, until a bout with shingles forced her to retire. Cavit died in 1987 and Hope passed on in 2001 after training her successor, Sarah Summerville. (All, courtesy of Unexpected Wildlife Refuge.)

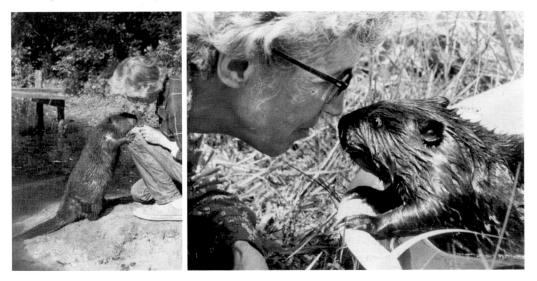

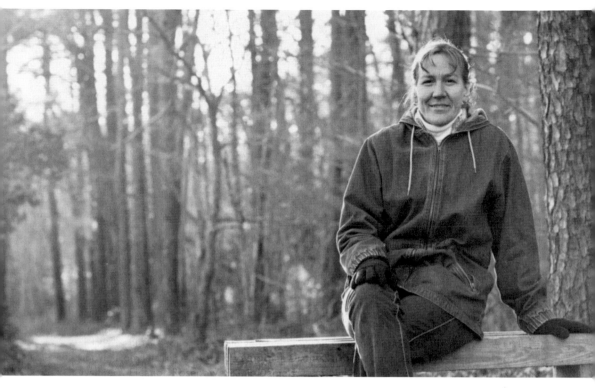

Sarah Summerville

Sarah Summerville first learned of the Unexpected Wildlife Refuge when she saw an article about Hope Buyukmihci looking for volunteers. She carried the story in her briefcase for a year and a half, never getting the chance to call. While she was taking a class to get her wetlands delineation certification, another student mentioned that a friend who owned a refuge was looking for help and suggested she reach out—it was the woman from the clipping, Hope.

As Sarah drove into the refuge, the paved road gave way to a bumpy dirt road. It was very remote but to Sarah it was magical. Something inside her said that this was it. It was June 2001 when Hope, using a cane, met Sarah for the first time outside her cabin. She asked her three questions:

"Can you drive a stick shift?" Sarah said yes.

"Can you split wood?"

"Never done that, but I can learn."

"Do you play Scrabble?"

She beamed. "Yes, I do, and I'm very good at it."

"Carry on," Hope said. Thus began a 13-year adventure that Summerville still relishes each day.

For the first three months, Sarah would commute to her job in Hammonton, drive back to Egg Harbor City for lunch and to walk her dog, return to work, then go back to her house, walk and feed her dog and change into work clothes, and then head to the refuge. She would work until dark and then play Scrabble with Hope.

In September of that first year, she was by the pond when a little beaver, the first one she had ever seen, came paddling over, looked at her intently, and then swam away. It was a defining moment for her. The next day, she gave notice at her job and moved to the refuge.

Summerville wore several career hats before coming to the refuge and feels that everything she did in the past was a little piece of the puzzle leading up to her current position. "It's like I'm supposed to be here," she says. "I have no regrets; it's been fun. I love what I do. Those were jobs, this is a life." (Courtesy of photographer Andrew Gioulis.)

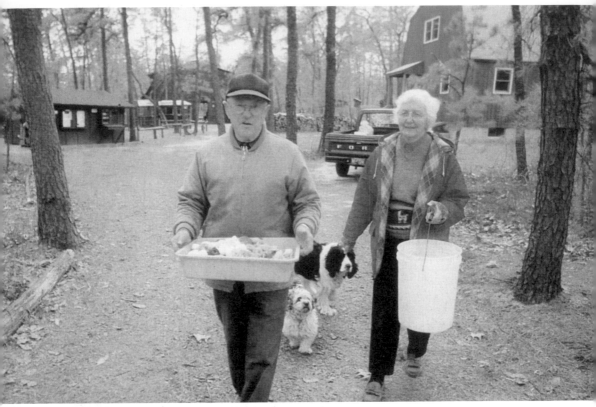

Jim and Betty Woodford

Jim and Betty Woodford owned a farm in Cinnaminson and spent summers with friends who had a cabin in Medford. They fell in love with the pristine woods and lakes, so when a nearby 185-acre parcel was put up for sale in 1951, the decision was easy. Avid birders, they became certified bird banders with the US Fish and Wildlife Service. Then someone brought them a baby great horned owl, beginning their journey operating a rehabilitation facility.

By 1957, they built a home on the property and established Cedar Run Wildlife Refuge. Educating the public was always a priority for the Woodfords, and Betty, an expert botanist and naturalist, taught adult education classes at Lenape High School in the Pine Barrens for years. Ted Gordon and his wife, Pat, were among her students. (Both, courtesy of Jeanne Woodford.)

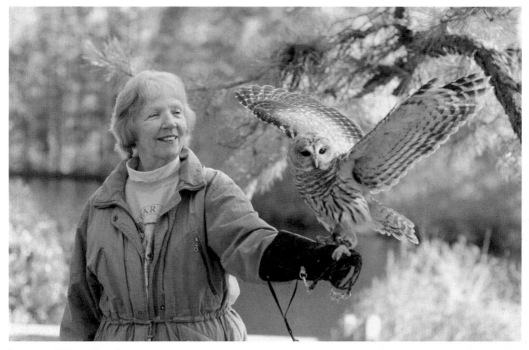

Jeanne Woodford

In high school when her family moved to Cedar Run, Jim and Betty Woodford's daughter Jeanne wanted to live in Mount Holly, where her friends were. Then the family found themselves snowbound for 12 days without electricity and gathered around to read John Greenleaf Whittier's *Snowbound*. Jeanne has many wonderful memories of swimming and ice-skating on the lake and taking people on canoe trips with her mother.

Jeanne taught special education and, with the permission of the board of education, would bring the students to the refuge once or twice a year at 6:00 a.m. to walk in the woods and learn about nature while her mother prepared pancakes for all. Like her parents, Jeanne is focused on education and is glad to see approximately 4,000 injured and orphaned animals come through the refuge each year. In 1981, the refuge was incorporated as a nonprofit with a board of trustees, of which Jeanne was president for a number of years. A wildlife hospital was added in 1986, and, today, the property has over 50 enclosures for temporary and permanent residents.

Jeanne recalls how when they first moved there, people asked them how they could "live in the sticks," but things have changed and, over the years, Betty turned away many a developer. In 1997, Jeanne signed an agreement with Green Acres to have the property permanently preserved from development, a decision she is most proud of. Even if down the road the refuge ceases to remain, Woodford Cedar Run will remain in its pristine state forever. "I knew I could choose no other path for Woodford Cedar Run because I had come to love and respect the Pines as much as my mother," Jeanne explained. Jeanne's brother's house was purchased as part of the agreement and now serves as the Elizabeth Woodford Pine Barrens Education Center.

Jeanne lived for a brief time in Maine and remembers coming back to the wonderful fragrance of the pines on a warm summer day and how there is nothing else like rounding a bend on the lake while canoeing and seeing a magnificent bird. Although Jeanne has scaled back some of her activities at the refuge, she still enjoys releasing a bird to the wild, one of the things she believes her father loved best. She recalls him saying, "It makes all of the hard work worthwhile when you can let a barred owl go and fly away and know that you have done something important and meaningful." (Courtesy of photographer Andrew Gioulis.)

Fred and Julie Akers

Julie Akers was content to be a stay-at-home mom until the prospect of Atlantic County locating a dump near their homes galvanized her and her neighbors into action. While they were successful in getting the county to build the dump outside the Pinelands region, it heightened their awareness of what they could do to protect the environment.

Her husband, Fred Akers, grew up camping, canoeing, and kayaking. When family friend and avid fisherman Warren Fox started catching deformed fish in the river, they decided to seek a Wild and Scenic designation for the Great Egg Harbor River and its 17 tributaries. Sen. Bill Bradley and Congressman Bill Hughes created acts of Congress to accomplish that, which was unusual, as almost every other designated river was on federal land. Julie went from town to town garnering support, and the designation was finalized in 1992. (Both, courtesy of Fred and Julie Akers.)

Pola Galie

Pola Galie has been coming to the Pine Barrens since she was a little girl growing up in Philadelphia and heard that the Jersey Devil made a stop in Philly. Galie was the outreach coordinator for the Conserve Wildlife Foundation for New Jersey and she is now the operations manager for the Natural Resource Education Foundation of New Jersey, formerly the Lighthouse Camp for the Blind.

Galie has immersed herself in the Pine traditions: basketmaking, fiber weaving, playing the mountain dulcimer, rabbit hunting, and the list goes on. Back in Colonial and Civil War days, before most women were regularly educated, they taught themselves through embroidery and needlework—using it to learn geography and math—and this has fascinated her since she was a little girl. (Courtesy of photographer Andrew Gioulis.)

McDuffy "Duffy" Barrow Jr.

Growing up in urban areas made McDuffy Barrow Jr., or "Duffy," as he is known to most, make a third-grade vow to move to "the country" when he was old enough. He has now settled in Barnegat, a place specifically chosen for the amount of public landholdings, so that he would always have a place to explore close to home. What Duffy loves most about his home is the diversity between the Pines and bay and that "every day brings new experiences, some of which I find absolutely amazing, and I am certainly never bored."

Duffy graduated with an English degree from Jersey City State College because he was concerned that so many of his high school classmates did not see the relevance of what they were being taught, so he went on to teach English for almost 32 years before switching over to work for the New Jersey Forest Service. He now has the added perk of working with students who deeply enjoy the learning experience, and, as an educator, he feels that there is no greater or more rewarding feeling in the world than to see his students "get it."

He has spent more than 13 years working for the Forest Resource Education Center (FREC) in Jackson and more than 20 years volunteering for the New Jersey Division of Fish and Wildlife, monitoring an endangered peregrine falcon nest in Manahawkin. He was selected as the Forsythe National Wildlife Refuge's Volunteer of the Year and is an active member of the Barnegat Township Garden Club and Shade Tree Commission.

As a master decoy carver, Duffy has led hands-on workshops in making waterfowl and shorebird decoys, cedar kayak paddles, turkey calls, fish carvings, and traditional oak baskets. He has also been the naturalist-in-residence for over 10 years at the Natural Resource Education Foundation (NREF) in Waretown, documenting more than just the species of birds. He has developed outdoor learning stations at both FREC and NREF, as well as wildlife habitats, animal signs, and a dozen rain gardens at area schools.

In his younger days, Duffy was always fascinated by the experiences shared by old-timers, but he has come to realize that people can have similar, exciting experiences if they spend enough time outdoors to be rewarded by the treasures it has to offer. Instead of traveling to exotic locations, he urges people to discover all the richness that the Pine Barrens has to offer in their own backyard, and he is happy to guide them on that special journey. (Photograph by Kathy Clark, courtesy of McDuffy Barrow Jr.)

Janet Larson

Janet Larson is the granddaughter of Betty and Mort Cooper, longtime environmental activists for whom the Cooper Environmental Center, at Cattus Island in Toms River, is named. The Coopers were part of the Pine Barrens Coalition efforts in the 1960s and 1970s and were involved in protesting the jetport proposal and subsequent development in the area known today as the Pygmy Plains.

This was Larson's introduction to conservation, which led to a career educating the public with Rutgers Cooperative Extension, as well as stints as president of the Ocean Nature Conservation Society; secretary of the Cattus Island Advisory Council; chairperson of the Dover Township Environmental Commission, which helped with the formation of the Ocean County Shade Tree Commission; and president of the Association of New Jersey Environmental Commissioners. She was also a member of Soroptimist International of the Americas and was elected to its hall of fame. (Courtesy of Soroptimist International of the Americas.)

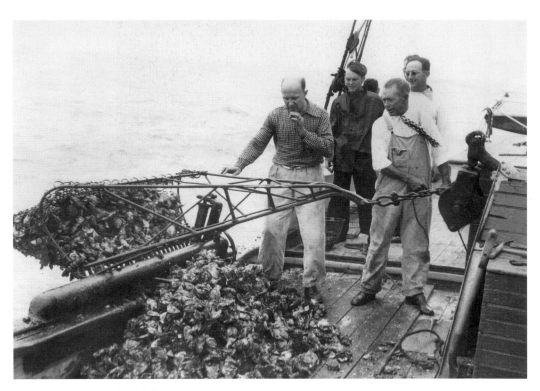

Walter J. Canzonier

At its peak beginning in the 1890s and extending into the 1920s, the Delaware Bay produced an average of three million bushels of oysters annually. In the early 1800s, oystermen used tongs, but once they discovered patches of oysters in the Maurice River coves and dredging began, the wild population became depleted. The industry then brought back densely set oysters from Virginia that were unknowingly contaminated with the parasite Dermo, which was fatal to oysters but not to humans.

Walter Canzonier was fresh out of school in 1957 when he began to work at the Haskin Shellfish Research Laboratory, part of the Rutgers New Jersey Agricultural Experiment Station. That year, researchers started to see unusual mortalities. It was determined to be a new "bug," which they labeled MSX for the multinucleated sphere properties they were seeing under the microscope. Almost 90 percent of the oysters succumbed in 1958, and many local companies filed for bankruptcy. (Above, courtesy of the Bayshore Center at Bivalve; below, courtesy of Haskins Lab.)

Lois Morris

While Lois Morris has since returned to her Indiana roots, for over 20 years, she left an indelible impression on her Crestwood Village neighbors and others whom she educated about the Pine Barrens. She first looked at homes on Long Beach Island in order to be near the shore, but realized that she was too much of a "people person" to be that isolated.

After moving to Whiting in 1975, she joined the Ocean Nature and Conservation Society. There, she met naturalists Howard Boyd, Elizabeth Meirs Morgan, and Dorothy Hale, who introduced her to the flora and fauna of the Pine Barrens through books and meetings. In turn, Morris started the Crestwood Stroll, a monthly hike to areas like Double Trouble, Webbs Mill, and Brigantine, where she educated attendees on what she had learned.

She also led field trips for the Pinelands Preservation Alliance and taught a "Birding and Botanizing" adult education class in Manahawkin. On Monday mornings in the summer, she would take conference attendees at America's Keswick on field trips so they would have the remainder of the week, if they were interested, to explore the area she introduced to them.

Morris felt that the more people who knew about the Pine Barrens, the better; and her popular tours drew as many as 100 students. Her hikes included an assistant who would use a long stick to point to the plant Morris had been discussing so those in the back of the group would not miss out. She had two simple rules: she was the only one allowed to talk or to pick anything, which she seldom did.

Her mother was a botanist who made a point of taking Morris and her brother to state parks on summer vacations, which she found boring as a child. She was surprised to learn how much she loved bogs as an adult, and Webbs Mill was her favorite spot. Despite her contracting both Lyme disease and ehrlichiosis, a "cousin" of Rocky Mountain spotted fever, her desire to share all she knew never waned. (Courtesy of the Pinelands Preservation Alliance.)

Terry O'Leary

According to him, Terry O'Leary has retired at least six times, but, fortunately, he is still out in the woods, educating and aiding naturalists and students and always ready to take on a new project. It all started for him when, around the age of nine, he tried to sell clams that he had caught up north that summer and people refused to take them because they said the bay was polluted. He did not know what that word meant.

Today, O'Leary is an expert on all things environmental, having devoted his life to learning from mentors like Dr. V. Eugene Vivian. He holds a master's degree in environmental science from Glassboro State College (now Rowan University) and was recruited by Pinelands Regional High School when it initially opened to teach environmental science and field ecology. It was the first high school in New Jersey to offer environmental science as a subject.

While there, he developed the Pinelands Experience, a three-day, two-night residential environmental education program. He and his wife, Cathy, took students for the bonding experience that the high school wanted while teaching them from 7:00 a.m. to 11:00 p.m. about the ecology. The program was so successful that it is still being offered today—by one of the first students to take Terry's program.

After leaving Pinelands Regional High School, Terry and Cathy started their own business, Cedar Hollow Landscape Design and Environmental Consulting. In this capacity, they did endangered species work, wetlands mitigation, and landscape design, and built rain gardens for those wanting to get a permit to build in the Pinelands, as it was required to show that property owners were putting in appropriate and compatible plantings.

Terry also worked with Dr. Vivian on and off for 25 years, part of that time at the Conservation and Environmental Studies Center in Whitesbog, where he also lived. He was also instrumental in establishing the Natural Resource Education Foundation of New Jersey and the Barnegat Bay Decoy and Baymen's Museum (now Tuckerton Seaport) and was the educational coordinator for the Forest Resource Center in Jackson for 12 years.

Terry received the Guardians of the Bay Lifetime Achievement Award from the Barnegat Bay National Estuary Program in 2007 and was inducted into the Pinelands Preservation Alliance's Pine Barrens Educator's Hall of Fame in 2008. What has mattered most to Terry is the chance to mentor the next generation, to put an imprint on a young person and hope that he or she will run with it and continue to pass it down the line. (Courtesy of Terry O'Leary.)

Michael Mangum

Mike Mangum has been with the Ocean County Park System for 36 years, starting as a naturalist and currently serving as director. His role over the years has been to take people out and teach them about the Pine Barrens, through hikes, canoe trips, nature programs, and interpretative programs, or about the park's design, development, and signage.

Besides his role in the park system, Mangum has also worked with the New Jersey Forest Fire Service part-time on major fires and on the incident management team. He considers himself to be an expert on fire ecology—why the Pines are here and why they continue to be. In his role as an educator, he has talked to audiences who do not know anything about the area and those who are quite knowledgeable and looking to learn more. He was on the Tuckerton Seaport's board of trustees and enjoys helping people learn about the bay, which is also a key part of the region that many often forget.

Bud Seaman suggested to Mangum that the parks department start a decoy show, and, in 2012, the annual Ocean County Decoy and Gunning Show celebrated its 30th year. The focus of the show is to give people a living history, and, to that end, organizers try to keep everything as authentic as possible. The decoys float in a lake, not in a kiddie pool, and kids learn decoy carving, duck calling, and actual hunting skills. The department also presents an annual Hurley Conklin Award to recognize people who may not have been honored before.

Mangum tried to do something similar with the annual Pine Barrens Jamboree in Wells Mills Park, only the focus there is more on honoring the old times, with music and crafts being the central theme. Like with the decoy show each year, someone—or something; last year it was the *Hindenburg*, since it was the 75th anniversary of its explosion—is honored, and planners try to get in writing some of that person's history. Many of the previously honored folks have passed on, Mangum notes.

He hopes that "whatever we've done along the way trickles down to future generations and they appreciate what we have here and take the time to learn about the Pine Barrens. Most of the people here today are not from this area and so they don't have the basic knowledge of folks in past generations that were more intricately related to the land." (Courtesy of Mike Mangum.)

Paul "Pete" McLain

By the early 1960s, the peregrine falcon, osprey, and bald eagle populations were in massive decline. Some believe that the population losses were due to the effects of widespread spraying of the pesticide DDT, while others blame the extensive reduction of wildlife habitats. Whatever the cause, the peregrine falcon population had been extirpated east of the Mississippi River. That is when Pete McLain stepped in. As deputy director of the Department of Environmental Protection's New Jersey Division of Fish and Wildlife, McLain was instrumental in getting the New Jersey Endangered and Nongame Species Conservation Act passed in 1973.

He then partnered with Dr. Tom Cade, a professor of ornithology at Cornell University, where McLain had graduated with a degree in wildlife management. Dr. Cade was experimenting with "hacking" falcons, a process of providing captive-bred young with a sheltered experience while learning to fly and hunt to give them a "soft release" into the wild, and was looking for a state willing to participate. In 1980, New Jersey became the first state east of the Mississippi to have a wild nesting program, at Forsythe National Wildlife Refuge.

McLain is also an avid wildlife photographer, and a film he made, *Return of the Peregrine*, received the Best Conservation Film Award in 1978 from the University of Montana. McLain was also successful in increasing the populations of ospreys and bald eagles in New Jersey.

But even before he started working to restore bird populations, McLain was instrumental in benefitting wildlife in New Jersey. He conducted the first surveys of eelgrass beds in Barnegat Bay and worked to acquire thousands of acres of open space, most notably Colliers Mills Wildlife Management Area in Ocean County and Sedge Island, as part of New Jersey's first Marine Conservation Zone, along with Island Beach State Park.

McLain has received numerous recognitions for his work, including the Guardians of Barnegat Bay Lifetime Achievement Award in 2005, the Barnegat Bay Champion Award from the New Jersey Audubon Society for over 50 years of dedication protecting the natural resources of the Barnegat Bay watershed, as well as the group's 1986 Award of Merit for outstanding contributions toward the preservation of the Delaware Bay Shorebird Reserve.

He and his late wife of 62 years, Anne, raised four children—Wendy, Nancy, Samuel, and Elizabeth. (Courtesy of Lisa Auermuller.)

Fred Lesser

Fred Lesser grew up around water and it is where he is the happiest. His family moved to Pine Beach when he was four years old because his father taught at Admiral Farragut Academy. His first interests were turtles and snakes, but because he spent so much time on the water, that passion soon changed to ornithology, a passion that is still going strong 60 years later.

He is particularly interested in marshes and shorebirds such as gulls, black skimmers, and terns, the latter of which many people mistakenly call gulls. Approximately every two weeks for the past 37 consecutive years, he has taken Dr. Joanna Burger from Rutgers out on his 17-foot Boston Whaler to do a census of colonial nesting birds in Barnegat Bay and Little Egg Harbor.

Lesser also works with Mary Judge of the Barnegat Bay Partnership on bird counts. It was on one of those treks that he saw something startling. A red bat was circling overhead when suddenly it was snapped up by a Cooper's Hawk. Lesser was not aware that they would eat bats, and seeing unusual activity like this is what draws him to birding. Lesser has often seen mink, otter, and coyote in the woods, and when people register surprise at this, he tells them that it is just a matter of keeping their eyes open and looking for anything unusual.

He admits that he has never been a photographer, unlike many other birders, because he feels he does not have the patience and he would rather focus on watching the bird and its behavior in his binoculars than trying to line up the perfect shot.

Earlier in his career, Lesser worked for the Ocean County Mosquito Commission for 10 years. He has now been with the Ocean County Parks Department for about 20 years, first at Cattus Island and now at Wells Mills. Lesser holds degrees in forestry, wildlife management, and entomology.

Another unusual and exciting find has been the arrival of several rare, nonnative birds in the area. Several pink-footed geese and barnacle geese, which used to nest in Iceland but migrated to Greenland because of global warming, have been spotted in Toms River recently. After Hurricane Sandy, several Northern Lapwings from Europe have taken up temporary residence in New Egypt, in a cow pasture, of all places. The cows are constantly churning up the dirt with their feet, exposing fresh worms for the birds to eat. (Courtesy of photographer Andrew Gioulis.)

German Georgieff

In search of more open spaces, Paterson native German Georgieff planned to leave the state after completing his forestry degree at Rutgers University. Roommates from the Pine Barrens, however, invited him to see all that this place offered, and, today, he is still amazed by new discoveries, which he incorporates into presentations in his job as chief park naturalist at Wells Mills County Park. He was surprised to realize that he would rather revisit a place in the Pine Barrens over and over again to learn all about it than venture to a far-off place like the Grand Canyon or overseas.

As a naturalist, he educates people on a variety of disciplines, from botany to endangered species, but in recent years, he has become more interested in the history of the Pine Barrens, as well as the railroads and lifesaving stations, topics that have became popular van tour presentations. He admits that, at one time, he was content to just identify the plants in an unfamiliar area, but now when he discovers nonnative species, indicating that man had an influence in that area, he yearns to know what brought that about.

German's grandfather was an Italian stonemason who hoarded materials from old buildings being torn down, and German was curious about their origins as he helped load bricks into his grandfather's truck. Helped by the advent of the Internet, he now enjoys researching the bricks that have piled up in his yard since childhood, looking up the manufacturers and what became of the companies.

An undiscovered road, for instance, makes him curious what it once led to—a glass factory, perhaps, or a cranberry bog? He is fascinated with industry and transportation. When trains went through an area, it was usually for reasons other than carrying passengers, such as freight—bricks, cranberries, glass—and so the two were inexplicably linked.

Like many others, German is concerned about environmentally sensitive areas being lost to development at an alarming pace. More difficult is the fine line between making people aware of the locations of decaying ruins of ghost towns and the need to protect the ruins from possible later vandalism. He feels that history does not belong to just a few people and that making folks more aware of what this area offers may inspire them to put pressure on the government to enact protective measures. (Courtesy of photographer Andrew Gioulis.)

Mickey Coen

As a college student, Mickey Coen probably did not realize how his degrees in health, physical education, and recreation were going to intersect to develop a career he loved and hold the key to protecting something very important to him. In 1975, he was hired by the Ocean County Parks Department on a part-time basis to develop a recreation program. The department was looking to channel funding into programs utilizing local natural resources, namely the coast and the Pinelands.

That first summer, he canoed and did a lot of research, which formed the basis for a booklet on canoeing in Ocean County and the surrounding area. It provided distance, scenery, fishing, history, and average trip times for the waterways in the region. Eventually, besides the booklet, the Ocean County fishing contest, the annual fall Toms River Canoe Race, and two nature centers, at Cattus Island and Wells Mills, sprang out of that funding and research.

One of Coen's biggest challenges was promoting safety on the rivers. Armed with just a little bit of knowledge and the desire to discover nature, one will see so much more on the bank of a stream than walking in the woods. Various reptiles and aquatic creatures can be easily observed and enjoyed from the enviable position of a boat, and many recreationalists say it is the best way to discover the Pine Barrens.

About 22 years ago, a builder wanted to develop a section in Lacey Township and, since the Pinelands Act had not been tested that much at the time, Coen feared it was going to go through. He got involved with the Forked River Mountain Coalition and has been on the board of directors ever since. The coalition set a target area of 20,000 acres to save, using the Garden State Parkway to the east, Lacey Road to the north, Greenwood Forest to the west, and Wells Mills Road to the south as the boundaries. In the center of that lie the Forked River Mountains. To date, the group has preserved almost 7,000 acres with the help of a number of visionaries, including the Nature Conservancy, the New Jersey Conservation Foundation, and the Ocean County Freeholders. Coen learned a long time ago that in order to prevent development, conservationists must own the land, as homeowners cannot be trusted not to sell to developers when a deal just looks too attractive. (Courtesy of photographer Andrew Gioulis.)

Dr. John Wnek

Growing up in Essex County, Dr. John Wnek liked to catch salamanders and earthworms. Around the age of 12, his family moved to Barnegat Bay, although he had been coming to the area much earlier than that to visit relatives. In the late 1990s, he worked with Terry O'Leary and Christine Raabe to get the Lighthouse Camp for the Blind in Waretown into the public's hands, as the original Fish and Wildlife Service plan called for knocking the buildings down. Wnek dealt with the insurance and nonprofit aspects of saving and preserving the camp.

A few years earlier, a share-time program focusing on marine and environmental science had started with Ocean County Vocational and Technical Schools called the Marine Environmental Science Program. At the beginning, about 25 students attended, with one group in the morning and the other in the afternoon, but as the program grew, it became clear that there was a need for a concentrated school.

So, the Marine Academy Technology and Environmental Science (MATES) School was born in late 1990. Today, there are over 250 students enrolled in the school. There is a strong emphasis on the local environment and on the Pine Barrens in field science courses. About 350 student applications are received each year for the 70 available slots.

While Dr. Wnek works for the school in a supervisory and administrative role, he elects to teach at least one section each semester so he can identify with the teachers and students more. For example, he recently showed students how to use compasses so they would be versed in the technology that predated the GPS systems that are commonplace for students today. He hopes that his students will make a wider impact on the world, and he likes to see students have a lot of success and get involved in careers they are really excited about.

He has a bachelor's degree in biology and a master's degree in science education, and he believes that he is probably the only person who can say that turtles led him to Drexel, where he received his PhD in environmental science. It started when he learned that no one else had really studied them since Dr. Joanna Berger's research on terrapins at Rutgers in the mid-1970s. They were a model species and are an indicator of the health of an estuary because they are at the top of the food chain, so he began studying nesting sites of the northern diamondback terrapin on Sedge Island. (Courtesy of Terry O'Leary.)

CHAPTER THREE

Piney Traditions

Elizabeth Kite first coined the name Piney in 1912 when she was working on her thesis. She ascribed derogatory connotations to the name, including "inbred, drunkard, promiscuous" and "moron." Although years later, it was determined that she falsified her report, the negative feelings surrounding the term remained. Today, as always, Pineys are a proud, resourceful, determined group of people living in this region of New Jersey. Interestingly, not all resent the unearned reputation, seeing it as a way of keeping outsiders from disturbing their privacy, although it does on occasion draw the curious and ignorant.

Besides creating a culture with their own vocabulary, Pineys have a strong set of traditions, mainly following the seasons of the Pines. Folks like Bill Wasovwich were permanently immortalized in John McPhee's classic book *The Pine Barrens*. Wasovwich was 28 years old when McPhee wrote about him; today, he is considered one of the last of the Pineys who truly live off the land.

Joe Cramer embodies more of the "loner Piney," choosing to move out of his house into a shack nearly too small for just him and his dog, where he lived out the remainder of his life on his own terms. Charlie Weber Sr. and his son Charlie Jr. were the last of the salt-marsh hayers, an occupation terminated when the Pinelands Act preserved the land and prevented folks from removing natural resources, even if it was for a previous occupation. It probably did not matter because, apart from floristry, salt hay was only being experimented with for papermaking, which turned out to be a dismal failure in Harrisville.

Toby Kroll is a modern-day blacksmith who is determined to keep the old, traditional way of life alive. He owns both an older, more traditional blacksmith shed and a more contemporary one, but he takes the show on the road to educate audiences about a way of life that is most likely foreign to them. He also demonstrates at Batsto Village. He is currently training people to become blacksmiths in an attempt to keep this old art alive.

Baymen are also part of the fabric of the Pine Barrens generations—men who made their living at sea, usually only part of the year, and then moved inland to hunt, trap, moss, and work other trades in the colder seasons. Too often, this aspect of Piney life is forgotten or disregarded, as the woods are more commonly considered.

No matter where they worked, what they were called, or what they did, Pineys have a way of life that most can barely fathom. Highly resourceful, they are insulated from the rest of the world's impacts, be it economic recessions or Hurricane Sandy. Life goes on for them much as it always has, and as it did for their ancestors before them. Some have incorporated technology into their occupations to increase productivity, but their ingenuity and determination remains unmatched.

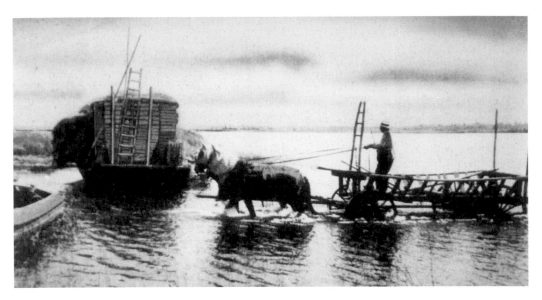

Charlie Weber Sr. and Jr.

Charlie Weber Sr. was known as the last of the salt hayers. He and his son Charlie Jr. (seen below blowing a horn to raise the drawbridge) would head out to the salt marshes, or "meadows," on a Monday morning and arrive back on Sunday. In July and August, Charlie Sr. would work from daybreak until dark. Then the men would sleep on the boat above in a deck shack, with an adjacent deck barn for their horses, Kate and Prince, and a shack on the other side for them. They would cut the livers from large sharks and hang them in the sun with a pan to catch the oil that dripped from them. They would then take paintbrushes and put the oil on the horses' bellies and legs to help ward off greenhead flies and mosquitoes. (Both, courtesy of Elaine Mathis Weber.)

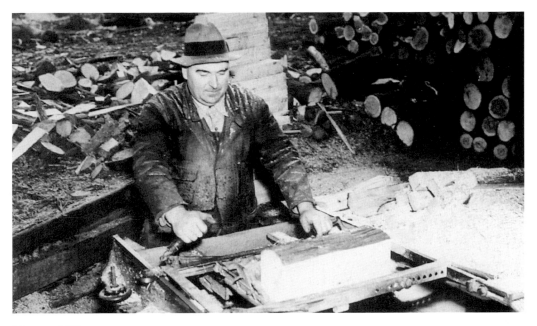

Howard Ware

Howard Ware's father worked in sawmills in Friendship, New Gretna, Lower Bank, Green Bank, and Clark's Landing. But he would not permit Howard to join him because he said that he had been working in mills for all those years and had nothing to show for it and did not want the same fate for his son. Ware remembers the summer in high school when he worked for Charlie Weber Sr. and Jr. in their salt hay business. Ware was responsible for cooking to feed the men; he was about 14 or 15 years old at the time. Ware also worked for his uncle briefly, and he recalls skinning 500 muskrats until midnight. For over 50 years, he worked as a carpenter; today, he grows vegetables in his backyard and sells them commercially. (Above, photograph by William Augustine, courtesy of Howard Ware; below, courtesy of photographer Andrew Gioulis.)

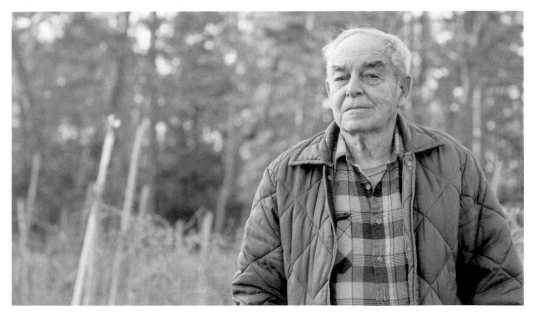

Alice Adams Weber

Alice Weber was one of four daughters and two sons (one son, Burrel Morten Adams, is seen in the inset image with her). She tended the Wading River drawbridge for many years and was very interested in the history of the town in which she was raised and lived. In 1959, she formed the Old Bridgeport Society. She was 75 years old at the time and concerned that the history would be lost to future generations.

For a number of years, she lived in the Leek-McKeen-Adams homestead, including during the time Henry Charleton Beck, the author of the Forgotten Towns of Southern New Jersey series, came by, but she ultimately moved to the house on the vee between Leektown and New Gretna Roads. She would charge visitors to land their canoes on her property and for the cost of a phone call to have someone pick them up. (Both, courtesy of Steve Eichinger.)

Steve Eichinger

Steve Eichinger was the first person to drive over the current Wading River Bridge. But his ties to the area waterways began at a much younger age. When he was four years old, his aunt Alice Adams Weber, seen above, would pack a lunch and bring Steve and her fox terrier Zepp, who would sit up in the bow, into the boat. Weber would tie Eichinger to the seat in the back with a clothesline so he could not get too far one way or another and fall overboard. She, of course, would row.

Eichinger recalls that catching one snapping turtle "wasn't too bad, but if you get two twelve-pounders and they get to fighting one another, they start raising the seat up and down [where he sat]." The photograph at right shows the proud four-year-old fisherman with his catch of perch. (Both, courtesy of Steve Eichinger.)

William Wasovwich

Bill Wasovwich will be forever frozen in time as the 28-year-old neighbor who visits Fred Brown in John McPhee's classic book *The Pine Barrens*. Time has not changed him much; Wasovwich is still as resourceful, hardworking, and almost as shy as he was when McPhee first penned his work for the *New Yorker* magazine in 1967.

One example of his resourcefulness is that he plants his tomatoes in pots and puts them on top of the roof of his unused van to keep deer from eating them. He also splits his own wood by hand, carefully stacking it to dry. He reminisces about all of the things he once got from the Pines: moss, grapevine, birch, laurel, and blueberry branches (the latter he bundled to sell to florists). Wasovwich has often been called "the last of the Pineys" for his strict adherence to living completely off of the land. (Both, courtesy of photographer Andrew Gioulis.)

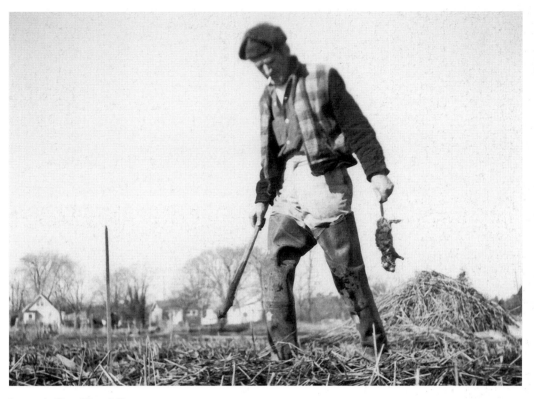

Joseph Bradford Cramer

Born on a winter's day in 1906, Joe Cramer was the youngest of three boys in his Bass River household. A descendant of the famed Van Sant family of boatbuilders, he worked in his relatives' shipyards, honing his skills.

After his parents died, Cramer remained in the family home until his nephew returned from the war, at which time he gave him the house and moved into a tiny shack at the water's edge that was barely large enough to hold him and his dog. His late niece Almira Cramer Steele recalled that moment as being the turning point when he decided to live not as the world lived, but on his own terms.

His interests included storytelling, reading, decoy carving, and repairing boats. He loved to tell tall tales to those who stopped by his shack to listen, and anyone admiring his decoys received one for free. Today, some of them are collectors' items.

Cramer had no responsibilities and took on none. His shack had no electricity and no phone, but it did hold a small potbellied stove. Since his dwelling was so small, the heat became so intense that he had to cut two portholes in the wall to let the heat out.

He never had a car; he either took a boat or had someone drive him if he needed to go somewhere. He owned a winter jacket, long underwear, boots, and not much more. Almira remembers seeing him wearing a piece of rope to hold his pants up, as he did not own a belt.

If he did not feel well, he slept for a few days and was disturbed by no one. He only went to the doctor's once, when he got a fishhook stuck in his arm; otherwise, he was content to rely on home remedies.

Cramer rolled his own cigarettes, and when he needed some money, he would catch and sell muskrats, known as "marsh rabbits." He was happy as long as he could provide food for himself and his dog Blackie, who probably ate better than he did. He also liked the occasional swig of brandy and never turned down anyone willing to treat him.

Although he was born on Valentine's Day, Cramer never married; it has been said, however, that he was engaged once. Some may consider him a recluse, eccentric, or odd, but he never harmed anyone, never cheated anyone, and never envied anyone. (Courtesy of Almira Cramer Steele.)

Toby Kroll

Blacksmithing was an important occupation, especially in the Colonial days, as blacksmiths were needed to shoe horses and make wagon wheels and other necessities like nails. Until the mid-1800s, blacksmiths relied on charcoal, which was made in nearby forests by colliers, until mined coal came on the scene. Toby Kroll is a third-generation blacksmith who learned the trade from his father. Today, he and his wife, Kate, also a blacksmith, own Three Cedars Forge.

Besides serving their client base, the Krolls also demonstrate blacksmithing at area events and at Batsto Village, where he teaches a blacksmith course. The Krolls have two shops, one resembling a typical smithy from the early 1900s and the other, a more modern one, filled with an assortment of hammers, tongs, punches and anvils, including one made in 1904 in Brooklyn. (Courtesy of photographer Andrew Gioulis.)

George Mick

James Mick remembers the smoldering teepee-shaped piles in his family's backyard at Whiting. His father, George Mick, was a collier, and it was his job to tend the charcoal pit until the process was complete and yielded charcoal. James remembers that a man then came around in a box truck to collect it. Charcoal was usually destined for New York or Philadelphia when George was a collier, in the 1950s. In the late 1700s and early 1800s, the pits produced charcoal to feed the bog iron furnaces and forges of the Pine Barrens. The glass factories also fired their furnaces with charcoal.

As a teenager, James would help his father cut turf and assemble the pits. They also had watchdogs who would watch the smoke coming out of the draft holes and bark if it got too hot, which would burn the wood instead of charring it—hence the word *charcoal*. (Courtesy of James Mick.)

Paul Bonnell (left)

Paul Bonnell says he grew up in Waretown in "the good old days when everybody knew everybody." As a teenager, he and his neighbor Sammy Hunt fished, trapped, hunted, and crabbed together. Bonnell was a lifelong fisherman, owning both a charter boat and a 75-foot commercial boat, as well as several garveys he made. He also ran the *White Star IV* and *Miss LBI* for a number of years.

Bonnell woke up ready to go at 4:30 a.m. every morning and would sometimes be gone for as long as two weeks on the boats, fishing off the Continental Shelf of Long Island and down as far as North Carolina. He caught bluefish, flounder, and cod in the wintertime. He says, "If we didn't get a couple thousand pound of cod a day, we had a poor day." (Courtesy of Terry O'Leary.)

Norman DuPont (right)

Every penny Norman DuPont ever made, he says, he made on the water. A lifelong fisherman and close friend of Paul Bonnell for many years, Dupont had a 40-foot charter boat named *The Linda* after a girl in town.

Although he was born in Lakewood, DuPont's family moved to Waretown when he was three, and that is where he smelled his first salt air. DuPont reminisces about how Waretown once served as a charter-boat town, but he says that now it is "the first page of the last chapter for the small town baymen." To his knowledge, he does not believe that there is one wild clammer or clam dealer until the bridge to Long Beach Island. He says, "The wild clammer for the most part is done. Farm-raised clams have taken over. If you want 50,000 clams, you can order them and they will ship them to you for 12 or 13 cents and there's no way you can make a living catching wild clams for that kind of money." It is a way of life that has slowly fallen by the wayside.

DuPont, like many on the bay and inland in the forest, worked the seasons. He recalls mossing—pulling sphagnum moss out of the woods and drying it to sell to florists—and, in the wintertime, sheathing the garveys with metal so they could be run through the ice. After he got out of the Army, he built a 26-foot garvey, which he used to clam in the summer and dredge crabs in the winter. He used fyke nets for flounder after bay scallop season was done, but even that has changed, and there is now a 38-fish limit.

When he was not in the water, DuPont enjoyed playing fiddle in two bands at Albert Music Hall—Piney Blue and Warm-Hearted Country. He learned to play the fiddle from his grandfather when he was 13 years old, but he says he played for the enjoyment and once in a while got paid.

DuPont was a member of the Pinelands Cultural Society and received the Hurley Conklin Award at the Barnegat Bay Decoy Show in 1997. He is currently 84 years old but he will always remember the time in Waretown when "all you could see, all you could hear, all you could breathe was the water—so many good things on the water. You think it's going to last forever." (Courtesy of Terry O'Leary.)

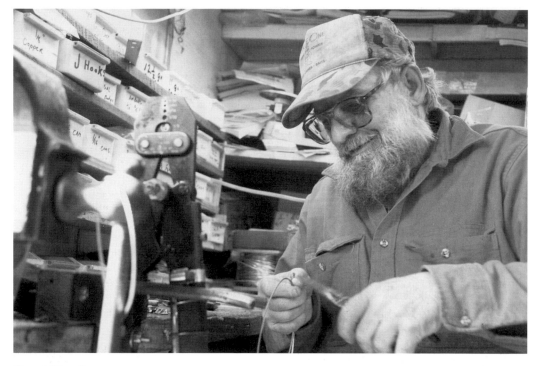

Newt Sterling

It was a 38-degree morning in January 2004 when Newt Sterling, John Scagline, Bob Jameson, and Johnson's Lab-golden retriever mix set course for the Edwin B. Forsythe Wildlife Refuge. Sterling had been hired by US Fish and Wildlife Service to trap predators such as otters, foxes, and raccoons to prevent them from eating the eggs of the endangered piping plover. Without warning, a high wave and a freak wind combined to catch and flip the garvey that Sterling had built, instantly plunging the foursome into 45-degree water. Not only were they at immediate risk for hypothermia, the part of the bay they were in was also isolated from most traffic.

With understanding and acceptance of their predicament, Sterling said, "I'm sorry. I killed you guys today." This calmness, the oneness with the cycles of nature, has enabled generations of Pineys and baymen to live off the land and remain in autonomy with it.

The motor had dragged one end of the garvey to the bottom, leaving the other end protruding awkwardly at an angle. Scagline is diabetic and was especially vulnerable. The men tried to help Scagline and themselves onto the hull but were unable to because of the strong waves. They had lashed a canoe to the garvey before leaving shore, and they took turns diving to find it. Even though they knew this exertion decreased their chances of survival, their thoughts were on saving the others.

Sterling and Jameson finally freed the canoe and tried hoisting Scagline into it, but his waterlogged clothing caused the boat to roll and spilled them back into the water. On one attempt, as Scagline began to sink, the two men dove for him as the canoe drifted away.

They made their final petitions to God, and Sterling recalls being filled with peace as he reflected on a lifetime of doing what he loved every day—hunting and trapping. They had been in the water for three hours when the captain of a distant boat caught sight of the wayward canoe. Following the unwritten law of the sea to investigate anything unnatural, he located and rescued the men and the dog. Had Sterling and Jameson not tried so hard to save Scagline, they may not have been discovered. Astonishingly, all three men and the dog survived. Scagline's wife told the doctor, "These men are hunters and trappers—they're a breed apart." (Courtesy of photographer Andrew Gioulis.)

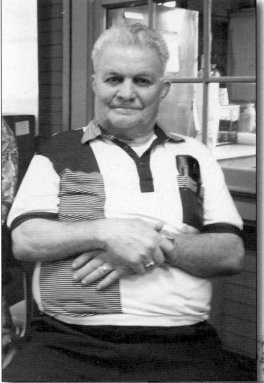

Cliff Oakley

Many people "met" Cliff Oakley over the years without even realizing it was he. Oakley dressed up as Smokey the Bear and the Jersey Devil for numerous community events. What was astonishing was that he was afraid of heights but was willing to be lowered down from a helicopter while playing Smokey the Bear. Everyone loved Smokey, but the same was not true for the Jersey Devil. He was punched, kicked, and even had a few ribs broken, with the abuse coming from both children and adults.

Oakley will always be remembered best for his wonderful storytelling ability, a Piney tradition to try to "pull someone's leg" to test gullibility. His "Wells Mill Frog Farm" story received the largest listener audience on radio station WOBM when it aired, and, although Oakley has passed on, many still remember Toby the frog. (Both, courtesy of Terry O'Leary.)

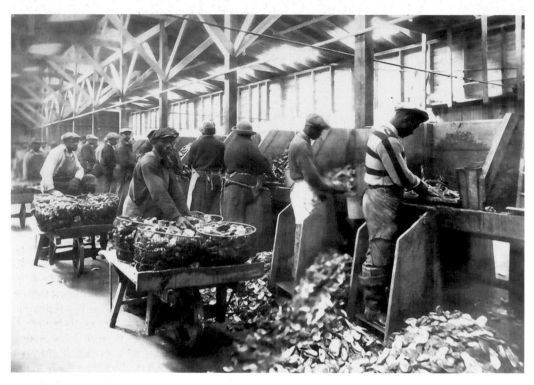

Clyde Phillips

Clyde Phillips remembers the day he first saw her in 1947—a 95-foot schooner tied to a tree along the bank of the Maurice River. He was in high school at the time. Every weekend, he and his brother and father would pump the schooner, the *A.J. Meerwald*, dry so it would float. He recalls it being "hard work for boys."

The Meerwald family commissioned the boat to be built in 1928, and, in 1942, it was commandeered under the War Powers Act and outfitted as a fireboat to be used during World War II. After the war, it was returned to the Meerwalds, who sold it to Phillips's father, who renamed her *Clyde A. Phillips* after himself and completely rebuilt her to use as an oyster dredge. He had the boat for 10 years until his death. She was later retired and then donated to the Bayshore Discovery Project. In 1998, Gov. Christine Todd Whitman designated her as New Jersey's official tall ship.

The younger Phillips grew up in Port Norris and went swimming every summer in Bivalve until high tide came in, bringing with it everything from dead pigs to human bodies. Crews worked on the oyster boats from "can to can't," as the older Phillips would say—from the time a person can see until the time he cannot. Clyde A. Phillips was instrumental in writing a law to reduce the workday to eight hours and in organizing unions so the workers received fair pay.

At the time, the men worked for $12 a day if they brought their lunch aboard, or $10 if they wanted three meals. Clyde A. was one of the few that had a cook onboard, and the younger Phillips recalls that the meals were plentiful, with hand-baked bread, cakes, and pies. Most workers opted to bring their own lunch to earn the extra $2.

Phillips's grandfather was also in the oyster business. Around 1900, oysters were America's top fishery product, and New Jersey was the leading supplier. At its peak, more than 4,000 people and 500 schooners worked in the Maurice River area bringing in oysters. Port Norris was said to have more millionaires than anywhere else in the country at the time.

Phillips remembers starting out with a small boat while still in school. With four grounds from which to harvest, he was able to make back his $27,000 investment in just three months. (Courtesy of the Bayshore Center at Bivalve.)

CHAPTER FOUR

Artisans

The Sounds of the South Jersey Pines is what locals flock to listen to on Saturday nights at Albert Music Hall. The hall is probably the best bargain in town; for only $5, there are four hours of music, typically with four bands, and the evening finale, the Pickin' Shed Jam. If guests arrive before the 7:30 p.m. stage start—and most do—they are treated to listening to musicians tuning up, practicing, and playing outside on the porch or in the famous pickin' shed, where guests can bring their own instruments and join in.

It all started at Joe and George Albert's deer cabin, not too far from the hall, where musicians would drop by on Saturday nights to play. George played fiddle and Joe played the washboard. In the winter, the Albert brothers always had a pot of hot coffee going and wives would come by with homemade cake while their husbands jammed. Women played, too, with Janice Sherwood and Gladys Eayre of the Pineconers among the first. There was no electricity, but a roaring fire in the cast-iron stove and plenty of laughter kept everyone warm. In the summer, the windows were propped open and deer would wander the property.

After George died, the music stopped briefly until a group of musicians decided that "the show must go on," and a new home was found at the Waretown auction. After that burned down, money was raised to build a permanent home; and since January 1997, the music has rung out on Saturday nights at the hall.

Other artisans use their talents to represent the Pine Barrens. Terry Schmidt uses her paintbrush to take a familiar scene in the woods and help viewers see something new and want to explore it personally. Albert Horner and Michael Hogan have done the same through their viewfinders. Although both are amazing photographers, each employs different cameras, techniques, and passions to help locals and newcomers see the area in a new light.

Howard Boyd and Barbara Solem, while gifted in many ways, are probably best known throughout the area for the books they have authored, which acquaint readers with the flora, fauna, ecology, ghost towns, and history in the Pines.

Niki and Gary Giberson still live off the land in many ways and are actively teaching the new generation—as well as older ones—Early American history, crafts, and culture. Niki raises sheep on their property and can shear, spin, dye, and make clothes from the wool. She also has a berry garden from which she produces her homemade jams and jellies.

And despite her Hollywood success, Betty Jane Crowley, who went by Kathleen Crowley in film and television, knew the best place to raise her son was back in the Pine Barrens, where she was raised.

Each of these artists hopes that, through his or her gifts, people will become inspired to learn more and desire to permanently protect this magnificent region so it can be appreciated by future generations.

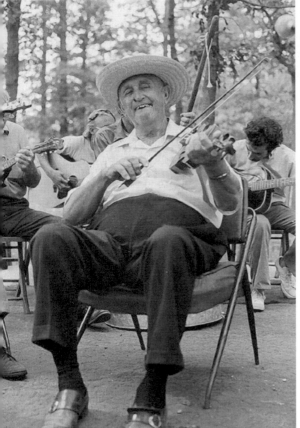

George and Joe Albert

In a small, secluded deer cabin in Waretown, brothers Joe and George Albert made their home. George played the fiddle and Joe played the washboard. Every Saturday night, the brothers and a handful of friends would gather at the Home Place, as it came to be called. With sparse furnishings and bunks lining one room, the musicians would join in a circle and play into the wee hours of the morning.

Wives would bring homemade cakes to share, and water came from a hand pump in the kitchen. In the winter, a roaring fire in the cast-iron stove kept visitors warm and gas lamps lit the cabin as there was no electricity. Word of mouth drew musicians from all over until George died and Joe could no longer handle the crowds. After that, the music stopped for a time until volunteers decided to find a new home. (Both above, courtesy of photographer Russ Herr; right, courtesy of Terry O'Leary.)

Roy and Elaine Everett and the Pinelands Cultural Society
On May 18, 1996, a small group of people gathered for the ground-breaking of the new Albert Music Hall. Seen above, from left to right, are clan mother Diane Caroline Krauthause, Marty Borsuk, Connie Borsuk, Russ Herr, Eleanor Rosenow, Frank Daniels, Joan McHale, Roy Everett (with shovel), Elaine Everett, Joe Horner, Gene Rosenow, Mary McGillick, and Chief Whippoorwill. The chief and the clan mother performed a Lenape earth blessing on the land where Albert Hall was to be built. They came back later and gave a Lenape building blessing at the building's dedication and first show, on January 5, 1997. For over 17 years, Roy Everett has served as president, webmaster, and booking agent for the shows, while his wife, Elaine Everett (both shown below), has been in charge of public relations for over 20 years. (Both, courtesy of Pinelands Cultural Society.)

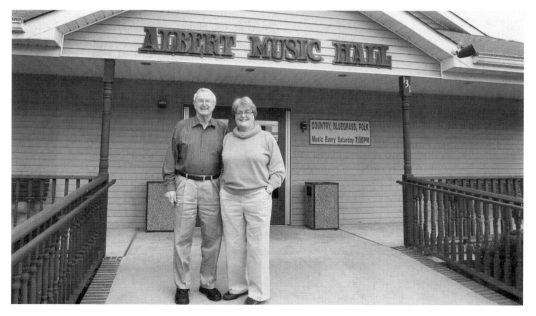

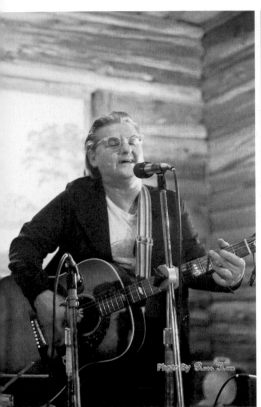

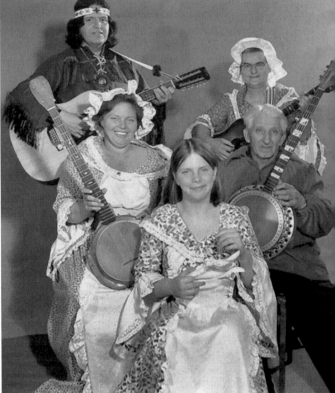

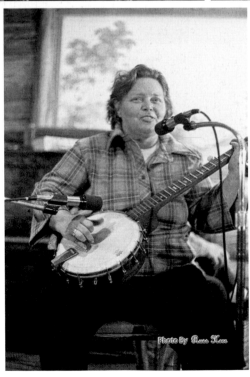

The Pineconers

The Pineconers were among the earliest groups to play at the Home Place, George and Joe Albert's deer cabin. Gladys Eayre (above left) was born on Wells Mill Road in Waretown, near the Home Place. Her mother died when she was seven and she was raised by her father and five brothers, two of whom taught her to play the guitar she received when she was eight. She spent many years as the caretaker for the Lighthouse Camp for the Blind in Waretown and her cousin Janice Sherwood (below left) worked as a nurse there as well as for the Lacey Township school system.

They played together as the Pineconers for many years, along with Sammy Hunt and Sherwood's daughter Katie (above right). Eayre was the first vice president of the Pinelands Cultural Society, from 1975 and 1983. (All, courtesy of Russ Herr.)

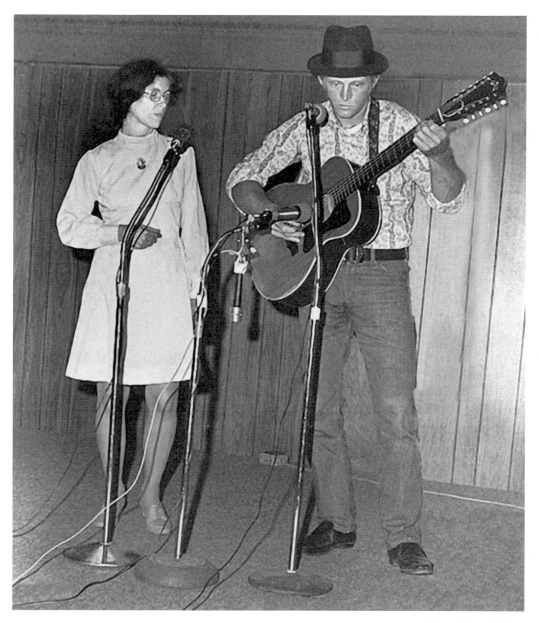

Merce Ridgway

Merce Ridgway is probably best known for the iconic book he authored about his lifestyle, *The Bayman*, which has been read and loved by many. Ridgway learned his way of life from his father, and his most treasured lesson was honesty. His father taught him to "always give the best package you can, an extra clam per hundred, as many big crabs, scallops and oysters you can get in a bushel, and throw the little stuff back."

Both Ridgways were musicians in their younger days, and the younger Merce misses Albert Hall and the Sounds of the South Jersey Pines, now that he has retired to a holler in West Virginia for health reasons and because of the environmental decline of the bay where he made his living. He credits his wife, Arlene, seen here with him, for her support and encouragement in helping make the world a better place. (Courtesy of Russ Herr.)

Jim Murphy

What most of Jim Murphy's fans do not realize is that he was a family man at heart, and that when he died in 2012, he left behind his wife of 59 years, Shelagh, as well as 6 children and 13 grandchildren. It was for his family that he got into education as a career, and he retired as the assistant superintendent of Brick Township Public Schools.

He was best known to them as the leader of Jim Murphy and the Pine Barons, a favorite Albert Music Hall act that was named Band of the Year by the National Traditional Music Association in 1998. In 2007, Murphy was the first inductee from New Jersey into the Old Time Country Music Hall of Fame, in recognition of his almost 45-year involvement with traditional country music. In 2008, Rutgers University presented him with a Lifetime Achievement Award at its Annual New Jersey Folk Festival. (Both, courtesy of photographer Karen F. Riley.)

Gabriel Coia

Gabe Coia's haunting ballad of the Mullica River, "Ageless River," was inspired by a passage in Henry Charlton Beck's *Jersey Genesis*. The Pine Barrens is an area steeped in sentimentality for Coia, as his grandmother has a house on the river and he has spent most of his life here, free-diving in the waterway and photographing it. One of his more surprising discoveries was finding a cave beneath the water's surface.

He graduated from Rowan University with a degree in music and cites Budd Wilson, Mark Demitroff, and Paul Schopp as his mentors. Coia plays and teaches guitar and piano and hopes to write a Pine Barrens–themed album. For now, he is content in bridging together his passions for natural science and history through his songwriting, dreaming here of what has been. (Courtesy of Marcus Coia.)

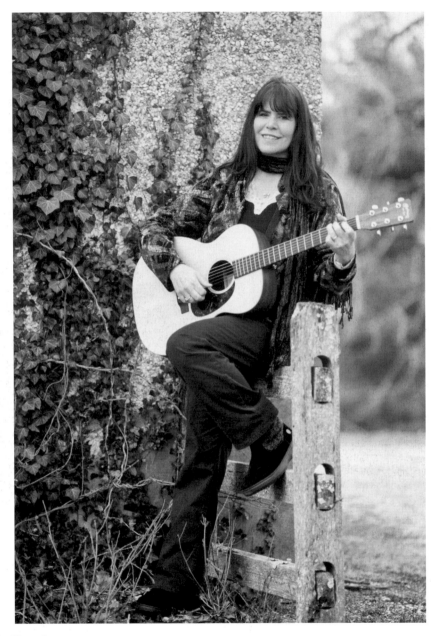

Valerie Vaughn

Valerie Vaughn came from a musical family. Her father was raised in Kentucky in a house that was always full of guitars, banjos, and violins. On Saturday nights, her father, brother, cousins, and she would hold their own musical jam. Vaughn was not schooled as a musician, but, by age 15, she was a good singer and performer. She sang in rock bands throughout high school and college. She has a degree in social work, and, in the early 1970s, she wrote songs about social change and having a social conscience. When she had her daughter, Vaughn began writing more songs for children—fairy tales and fun songs—and became known as the "mom with a guitar." As her daughter grew, so did Vaughn's music, and she started writing pieces about the Pine Barrens and was even named "New Jersey's troubadour." (Courtesy of photographer Andrew Gioulis.)

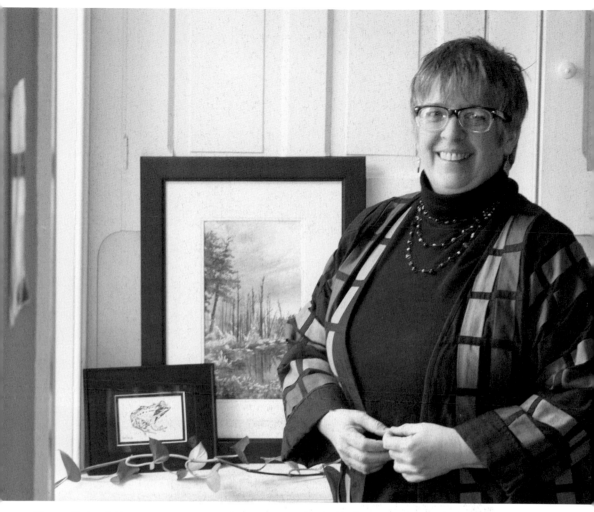

Terry Schmidt

As a child, Terry Schmidt loved to explore the woods near her home and was intrigued by small ponds, creeks, and historic remnants. Today, those discoveries splash and play across her canvas as her brush captures the quiet soul of a moment. She finds herself evolving as an artist as she takes familiar scenes and paints them from a unique perspective, helping the viewer to see something different.

Schmidt says that her family, friends, and the art community are very supportive and encouraging. She took her first art class at six years old and has been dabbling in illustration and watercolor paintings ever since. She grew up canoeing and camping and loves to be out in the woods every chance she gets. Her job at Wharton State Forest affords her the opportunity to help newcomers gain an appreciation for the Pines she loves so much. (Courtesy of photographer Andrew Gioulis.)

Albert D. Horner

Rising before dawn, Albert D. Horner can often be found perched on the roof of his vehicle, with his Canon 5D Mark II poised to capture the beauty of the Pine Barrens as the sunrise softly awakens the landscape. One of his favorite locations is the East Plains, where he can aim over the trees and record the movement of the sun across the landscape. He has also begun shooting video in the woods he has loved since he was a child.

Horner's goal is to help people see the area in a way they otherwise would not, so that maybe they will appreciate it more and want to preserve it. In this goal, he points to luminaries such as Ansel Adams and William Henry Jackson, whose photographs helped save some of the places out west they photographed. (Both, courtesy of photographer Albert Horner.)

Michael Hogan

Michael Hogan's passion for environmental protection and education is clearly evident in his nature photography. Shooting with a Calumet large-format camera has allowed him to not only make a living from his fine art but also to help countless environmental commissions and organizations throughout the area document their flora and fauna and preserve open space. He studied photography at the University of the Arts and works for the South Jersey Land and Water Trust.

Hogan's proudest moment was spearheading the drive to have a needed fish ladder installed at Batsto Lake, an area that his late father loved and where he first gained an appreciation for the beauty of the land and its history. Hogan also works with the US Fish and Wildlife Service, educating the public about swamp pink, an endangered plant, and helping preserve the remaining state populations. (Both, courtesy of photographer Michael Hogan.)

The Carty Family

Mary Carty's great-grandfather John Bozarth was a butcher who owned a meat market on Mill Street in Mount Holly around 1920. He delivered meat from door to door in Mount Holly and Pemberton using an oxcart.

Mary and her husband, Rich Carty, own Pinelands Folk Music Center in Mount Holly. Mary makes baskets out of natural fibers, interweaving local materials such as pine needles and deer antlers for handles. She gives classes in basketmaking in the back of the store.

Mary and Rich also played the dulcimer, an instrument originating in Appalachia, in a band called the Sunday Circle Dulcimer Players. Other members included Sue Seibel, Linda Kutsinger, and Carol and Jim Sweet, who went on to form Mountain Strings and the Sugar Sand Ramblers. Rich teaches the dulcimer and performs during the year. The Cartys' son Steven loved growing up in a musical and artistic family.

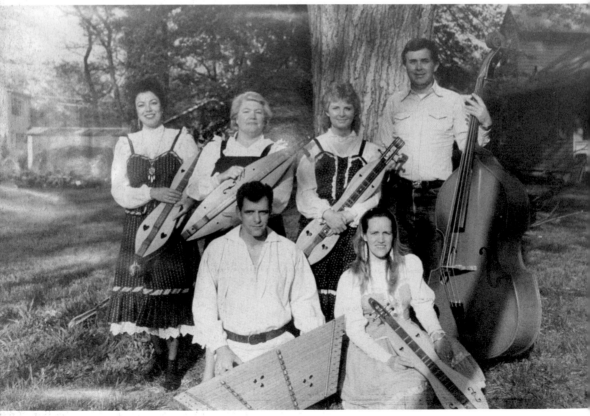

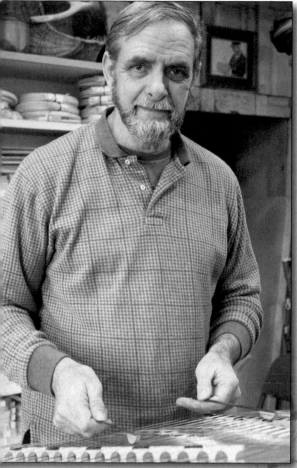

Having parents heavily involved in folk music provided young Steven with lots of travel opportunities. "It was also one of the things which gave me an early appreciation of the Pines culturally at an early age since they took us to Albert Hall often," he explains.

He became a professional weaver as an adult and is currently learning to play the harmonica. Steven's greatest challenge is overcoming his learning disabilities, especially when it comes to writing, which is a strong passion of his. He hopes to develop it as a profession alongside his basketry. He says, "The most rewarding thing in life for me has been every time someone has told me that I have either inspired them or influenced them in a good way. That is my idea of success." (All, courtesy of Carty family.)

Barbara Solem

Barbara Solem has lived in southern New Jersey for most of her life. Her career was in education, working as a special education teacher in Camden, then as a school principal and an education administrator for people with disabilities. But it was after she retired that her passion for the Pine Barrens really blossomed.

She did a lot of hiking and kayaking in the region. She would come across ruins that would incite her curiosity to learn more. Solem began taking her friends on ghost town tours, knowing that they would be as captivated as she was. She found it amazing to walk in places where a town of 400 people once prospered, to know that she trod on the same soil that workers in bog iron forges, paper mills, or glass factories once did.

Her first book, *The Forks: A Brief History of the Area*, was written to show people how important this area was to history. Smuggling and privateering took place here, and Batsto was the largest munitions maker for the Continental Army, and yet she felt so little was made of it.

Ghost Towns And Other Quirky Places in the New Jersey Pine Barrens, her second book, soon became a handbook for those wanting to know and find these forgotten places. The book raised concerns about revealing the locations of sites, but the decision to include them did not come easy for Solem. She believed that people connect more with history when they can experience it firsthand. In the end, she felt that most of the remaining sites were disappearing rapidly and it was more important to educate people about this history.

Solem has worked as a volunteer for the Pinelands Preservation Alliance, putting together its Heritage Speakers Series and cochairing the Pine Barrens Hall of Fame. Her favorite spot in the Pines is Atsion, and she currently organizes docents and helps develop the script for tours of the recently opened mansion. Solem just released a podcast tour of Atsion that received over 800 hits in its first week.

It is still her fervent hope that the more people know about the Pine Barrens, the more they will want to be a part of preserving it. (Courtesy of photographer Karen F. Riley.)

Howard Boyd

The future careers of many find their roots in childhood, and Howard Boyd is no exception to this. He grew up on small farms outside of Boston, and he recalled that, unlike larger farms, his family's did not have a building in which to store manure, so they tossed it outside the barn through holes cut in the sides. In the spring, they would remove the manure from the field to ready it for planting. One day, he noticed movement in the manure pile. They were large white grubs, which were actually scarab beetles in one of their life cycles. He began to look for other insects and thus began the journey that would lead to a master's degree in entomology from the University of Delaware and his becoming one of the world's leading experts on tiger beetles.

Boyd says it was the tiger beetle that drew him to the Pine Barrens; they proliferate in relatively dry, sandy terrains, and he considered the region to be almost an epicenter for the approximately 23 different subspecies. He said the word *fascinates* is probably the best way to describe his interest in tiger beetles' different colorations, their life cycles, and what and how they eat.

Another childhood passion also dictated a different career for Boyd; by the time of his high school graduation, he had earned every

nature merit badge in the Boy Scout handbook. He went on to receive a bachelor of science degree from Boston University with an emphasis on biology, and, after graduation, went to work for the Boy Scouts of America, retiring as an executive in 1969 after 31 years.

Boyd is also a botanist, the author of four books, and an editor, teacher, photographer, filmmaker, and naturalist. His first book, *A Field Guide to the Pine Barrens of New Jersey*, has introduced many to the Pine Barrens and is considered to be one of the most authoritative and widely referenced field guides to the flora and fauna of the region.

He spent nearly 30 years as the editor of *Entomological News* and served as president of the American Entomological Society for four years. He has received numerous awards, including the Paul S. Battersby Award from the Audubon Society in 1980 and the Silver Beaver Award from the Camden County Council of the Boy Scouts of America. He was inducted into the Pine Barrens Hall of Fame in 2004. (Courtesy of John B. Bryans.)

The Giberson Family

Niki Negus enrolled in Stockton College to become an animal behaviorist. An apprenticeship in spinning and weaving led her to switch her major to Early American crafts and culture. After graduation, she worked as a spinner and weaver in the Old Village at Smithville, where she caught the eye of resident decoy carver Gary Giberson. The pair married in 1978 and have three daughters—Amy, Megan, and Robin. When a fire gutted the Gibersons' home in 1986, the townspeople rallied to provide for them. To give back to the community, the family started Swan Bay Folk Art Center, where they teach historical crafts. Additionally, Niki makes her own commercially sold jams and jellies, is an accomplished basketmaker, and raises sheep on their property. Today, the Giberson ladies continue the tradition of handing down history through their blog, at www.swanbayfamily.blogspot.com.

A lot of people collect classic cars, but Gary Giberson, the mayor of Port Republic in Atlantic County, may be the only one who has collected an entire garage, not only of cars but the actual garage as well. He painstakingly built this life-sized model of a 1930s service station alongside his driveway in Port Republic from treasures he rescued on eBay. During the 17th century, his ancestors settled on 6,800 acres along the Mullica River, where the Atlantic white cedar, from which he carves his decoys, grows. He made his first commissioned sale at the age of 10 and has gone on to make carvings for presidents Jimmy Carter and George W. Bush, Jimmy Stewart, Jack Carter, Zero Mostel, Victor Borge, Ben Vereen, Ethel Merman, and Robert Young by "cutting away all of the wood that isn't duck." (Left page, courtesy of Giberson family; right page, courtesy of photographer Andrew Gioulis.)

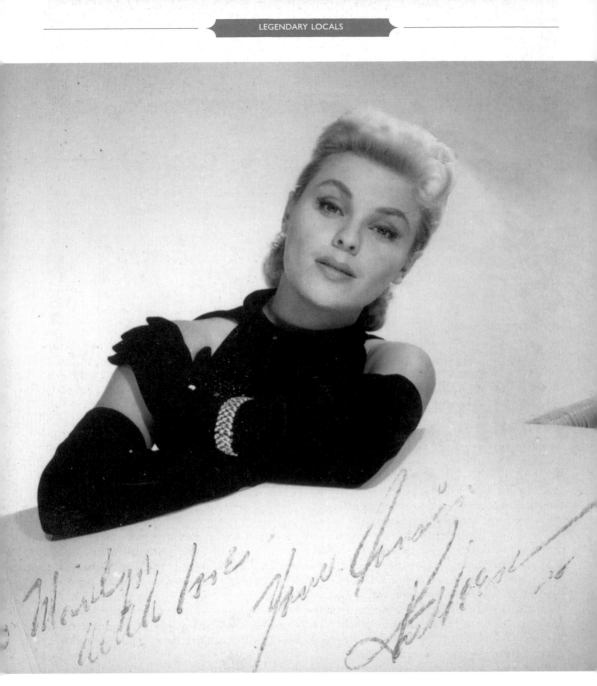

Betty Jane Crowley

Betty Jane Crowley grew up in Green Bank and was crowned Miss New Jersey in 1949. Back then, the contestants did their own hair. She paid $19 for the materials for her gown, which her mother made. She acted in movies and television under the stage name Kathleen Crowley. Her films and television shows include *A Star is Born*, *Jane Eyre*, *Bonanza*, *Thriller*, *The Virginian*, *77 Sunset Strip*, *Batman*, and many others. She was selected to be the first one to open the gates of Disneyland in California.

Hollywood, however, never changed the small-town heart of Crowley, and when she married John Rubsam and had a child in the late 1960s, they returned to her hometown to raise Matthew among family and friends. This photograph was autographed to her cousin, the late Marilyn Browne Wilson. (Courtesy of Budd Wilson.)

CHAPTER FIVE

Commerce

Like everything else in the Pine Barrens, even its businesses are unique. While there are the traditional sawmills, supply shops, and general stores, there are also many unusual twists.

Ed Bixby may have the most unique business in the area. When his infant brother died, he was buried in the local cemetery, which had an active congregation at the time. A few years later, the cemetery was sold and fell into disrepair, causing his mother to have a really heavy heart about having interred him there. She wanted to move him but was told there would be nothing left, as he had been buried in a wicker basket. Bixby, a developer, went to look at land next to the cemetery and decided to visit his brother's grave. He was appalled at the state of the place and told the owner it needed to be cleaned up, to which the owner replied he was not in a position to do so and gave the cemetery to Bixby. After doing research, he realized that the land met all of the qualifications for a green cemetery, and it is now the only one in New Jersey. Relatives can plan and be involved in every step of the process. While the services are dignified, Bixby sees it as celebrating the life of the person in a peaceful setting, and it allows a family to tailor a service into a very cathartic process.

Tom Snyder, a chemist, lived in a tent while constructing his luncheonette along what later became Route 206, which runs down the western side of the Pine Barrens. When complete, he moved into one of the six rooms upstairs while renting out the other five. So, the place was not only a luncheonette, but also a hotel. As Snyder was a justice of the peace, court was also held upstairs. After Prohibition ended, he decided to add a barroom and acquired the first liquor license in Shamong Township. After Snyder passed away, Pickett Russell Sr., Snyder's son-in-law, was a rodeo enthusiast, so riders would often stop in the bar, including Gene Autry and Will Rogers. When Pickett died, his funeral was held right there in the Pic-A-Lilli Inn. Later, a package store was added. Along the way, the inn has also been used as a hospital room and a wedding hall.

Again, Piney ingenuity, creativity, and dogged determination to solve problems often resulted in an opportunity that benefitted many folks for many years.

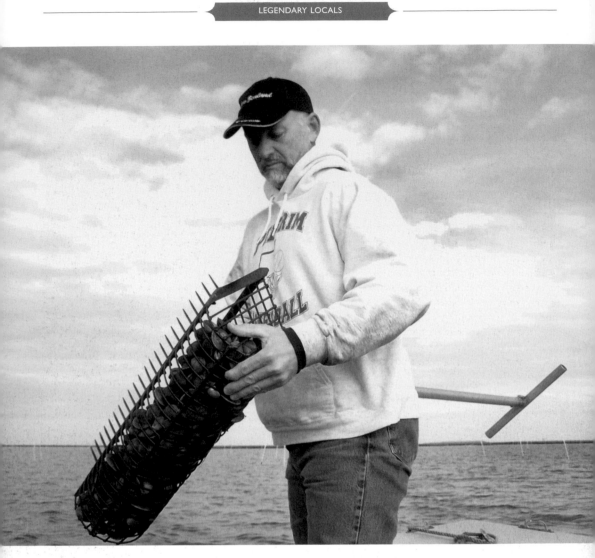

Rick Beckley

Rick Beckley is a full-time farmer, raising hard clams for a living. His father, Richard Beckley Sr., and Richard Crema were the first people in New Jersey to have clams spawn in a controlled environment. The clams are fed algae grown in a laboratory until they are big enough to plant outside in fiberglass raceways that water is run across throughout the summer.

In the fall, they are planted in beds out in the bay, where they continue to grow in the wild until they can be harvested in about three or four years. Once out in the bay, they are covered with a protective sheet, which has to be maintained to keep silt and seaweed off so they are not smothered. This technique was developed at the Virginia Institute of Marine Science back in the 1970s. (Courtesy of Rick Beckley.)

Ed Bixby

It started out innocently enough. Ed Bixby, a contractor, noticed the disrepair and refuse in the Steelman/Creamer cemetery, where his relatives were interred. At first, he set about tidying it up and then he started complaining to the owner, who did not have the time or desire to keep up the cemetery and told Bixby he could have it.

Having no idea what owning a cemetery entailed, Bixby began to do research. He realized that the place, bordering Belleplain State Forest and shrouded with cedar bogs and massive oak, pine, and cedar trees, could become the only certified green cemetery in New Jersey and one of 12 in the country. Using only natural burying methods, mourners can completely personalize their services and commit their loved ones back to the earth in peace and dignity. (Both, courtesy of photographer Andrew Gioulis.)

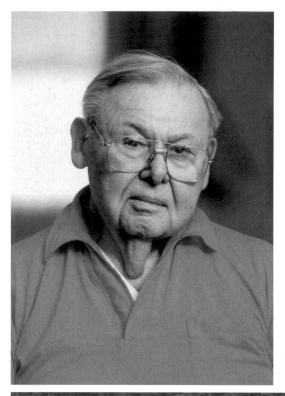

Archie Mazzoli

Archie Mazzoli started working in his father's business at the age of nine. At the time, Richland General Store was the one-stop shop for everything. Contained within its several buildings were a grocery store, a meat market, a clothing store, a shoe store, a hardware store, a gas station, a barbershop, a pool room, and, of course, the local gathering place where people came to stay abreast of the latest news.

The complex was simply referred to as Archie's, as father and son shared the same first name. At one time, it was open 24 hours a day and seven days a week—if someone needed something in the middle of the night, he could just call and it would be delivered. Now that he is retired, Mazzoli misses the customers, whom he considered family, most. (Left, courtesy of photographer Andrew Gioulis; below, courtesy of Archie Mazzoli.)

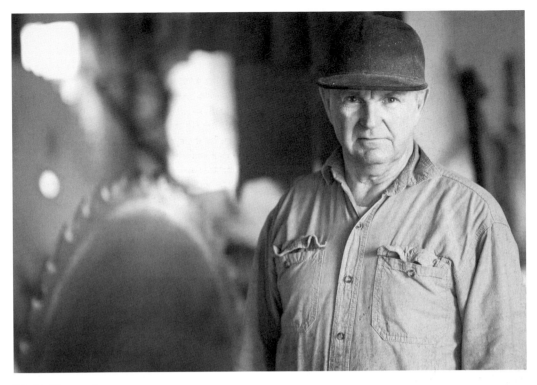

Walt Champion

Sawmills sprang up quickly throughout the Pine Barrens, harnessing headwaters to churn out lumber for houses, businesses, shipbuilding, and miscellaneous wares like baskets for packing produce or whiskey, Oak, pine, and cedar forests were quickly clear-cut as demand increased, prompting Benjamin Franklin, in 1749, to speak of the "reckless and wanton slaughter of the woods," as he urged that conservation practices be instituted.

Every town had at least one sawmill to supply its needs. Like most businesses in the Pine Barrens, they were typically passed down through the generations. Walt Champion continues to work in the Belleplain sawmill that his father started in the 1930s, although, with no children to be heirs to the business, it was put up for sale in December 2012. In the 1950s and 1960s, this was a thriving mill supplying basket parts to the produce-basket manufacturers in the area.

Walt and his brother Paul would go out logging while another brother, Tommy, ran the mill. Walt recalls the day that they were coming back with a load of cedar logs when their fourth brother, Bob, who went into the trucking business instead, came running out and jumped onto the running board of their truck, telling them that President Kennedy has just been assassinated. They had just installed a Frick mill that day, and every time he looks at it, he recalls where he was when Kennedy was shot.

Walt has been in the business his entire life, except for a two-year stint in the Army. He never wanted to do anything else, he says; it was a family partnership and none of them minded working. "You knew you weren't going to get rich, but you made money," he says.

He points out that one of the problems arising after their father passed away was that the three brothers each owned one-third of the business and there was no boss. Everything had to be decided by mutual agreement. He admits that there were squabbles, but "you got over it because as we got older, we realized we were wasting our energy and we didn't have it."

Walt now has a machine that nails up the boards for the palettes automatically instead of it being done by hand, which allows him to deliver 38,000 pallets per year to the one remaining customer, U.S. Silica. (Courtesy of photographer Andrew Gioulis.)

The Butterhof Family

William Butterhof (center, with sons Tom, left, and Mike) never dreamed that he would wind up on *The Dating Game*. But, one day, a producer stopped by to pick up supplies at Butterhof's home supply store for a farm-themed episode of the show and the opportunity arose. The production crew actually filmed part of the show on the family's farm and in the store, located on the White Horse Pike in Egg Harbor City. Although the television appearance made him an instant local celebrity, what he is most proud of is a letter from a noncustomer he never met. Several years ago, a Philadelphia man contacted him to purchase snow fencing. Butterhof knew the shipping costs would be prohibitive, so he made some calls and located a local supplier in Philadelphia. The man thanked him for his integrity with a beautiful handwritten note and a gift certificate for lunch on him. (Left, courtesy of Butterhof family; below, courtesy of photographer Andrew Gioulis.)

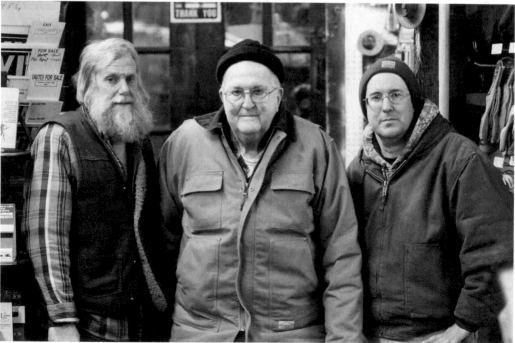

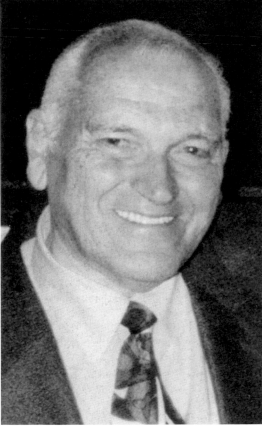

Herbert "Ted" Ellsworth

Born in an orphanage, Herbert Ellsworth was raised by a woman whose stepfather was a minister who worked with Dwight L. Moody. At the age of 12, she asked him to leave, and, feeling like "the luckiest guy in the world" to be on his own, he built a shanty in the woods, where he trapped and sold muskrats and cut wood for money.

He became a Christian at the age of 16 and attended Bethel Community Church, where he met Charlie Ashmen of Camp Haluwasa. Ellsworth then organized a Christian skate night, where he met his wife, Lorraine, with whom he had three children. He worked as a general contractor for 27 years, building golf courses, the Blackwood Medical Center, and several area shopping centers. His son Tim owns Southern Industrial Sand, which produces mix for baseball infields. (Above, courtesy of photographer Andrew Gioulis; left, courtesy of Lorraine Ellwood.)

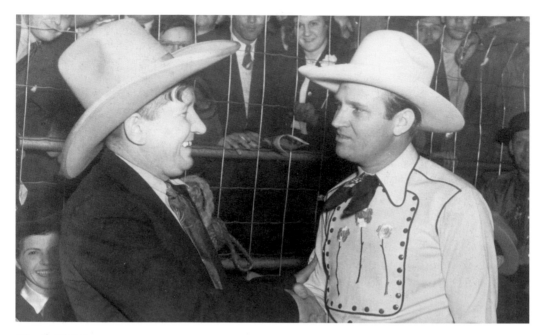

Pic-A-Lilli Inn

Tom Snyder, a chemist working in Camden, decided to open a business he called Snyder's Luncheonette on Highway 39, a dirt road that was later renumbered Route 206. He lived in a tent on the property while he was building. In 1927, he moved into one of the rooms upstairs, renting the others out as hotel rooms. He was also a justice of the peace, so he held court there as well.

After Prohibition, a barroom was added and the business was renamed Snyder's Tavern. After Snyder died, an employee spotted a jar of relish called Pic-A-Lilli and suggested it as the new name, since it included the names of Lillian, Snyder's daughter, and her husband, Pickett Russell Sr. (above left). The movie star and rodeo rider Gene Autry (above right), a friend of Pickett's, visited, as did Will Rogers. However, a goat named Billy was notably the tavern's most famous patron. (Both, courtesy of Pic-A-Lilli Inn.)

John Yank

John Yank left school at age 14 and went to work at a local boatyard, where he worked for over 20 years. Yank then started his own company on the Tuckahoe River in 1969, which has built more than 100 vessels, including 87 that are US Coast Guard–certified passenger vessels. Yank originally designed all of the boats he built, but his son John Jr. has been designing speedboats for the past 20 years. The 30-acre Tuckahoe site includes docking facilities and seven berthing areas, from 65 feet to 100 feet in length. In addition to building, the business also repairs boats up to 150 feet in length. Last year, the Tuckahoe facility also got a new 300-metric ton Marine Travelift. Its affiliate, Yank Marine Services, LLC, is located on the Maurice River in Dorchester. (Above, courtesy of the Yank Family; below, courtesy of photographer Andrew Gioulis.)

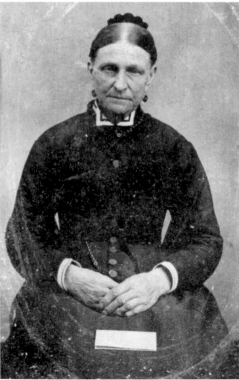

Catherine McKeen

Catherine McKeen was a woman ahead of her time. When her father, Robert McKeen, died in 1845, his will was probated and Orphans' Court ordered his properties to be sold. She bought the buildings and the property and, in the 1850s, used the house as an inn and tavern; it was highly unusual for a woman to run a successful business in that day. She never married and served as the Wading River postmistress from 1858 until her death in 1890.

In the 1880s, the buildings caught fire. As there were no banks in the area, people kept their money in coins hidden around their residences. There were no fire companies or ways to pump water from the river then either, so Catherine began throwing her hidden coins out the windows. As townsfolk gathered to watch the blaze, they began to quickly gather up the unexpected windfall. (Both, courtesy of Steve Eichinger.)

Larry Coia

Larry Coia (right), pictured with his son Stephen F. Coia, founded the nonprofit Outer Coastal Plain Vineyard Association in February 2009 to help other vineyards with establishment and promotion of sustainable and economically viable viticulture in the Outer Coastal Plain American Viticultural Area of New Jersey. This area is "devoted to the study and practice of grape growing in recognition of the fundamental importance of quality fruit in the wine industry triad of the grape grower, wine maker, and consumer." Its motto is *Fiat Vinum in Vinea*, or "let the wine be made in the vineyard."

The organization's goals include promoting and funding viticultural research, educating the community and consumers about the unique characteristics and quality wines produced in this area, providing members with discount purchasing of grape-growing material, and serving as an early warning network for vineyard problems. (Courtesy of Larry Coia.)

Karen F. Riley

Karen F. Riley, originally from Brooklyn, New York, moved to the Pine Barrens in 1992 after 30 years of city life. Seeking to escape the congestion of New York, she, her husband, and three children settled on a pristine piece of land on the outskirts of New Egypt. Although Karen had finally moved to the countryside, it was not until years later that she found herself discovering the true richness of the Pine Barrens.

Attempting to prevent a large housing development from being built directly across the street from her home, Karen used her lifelong writing and journalism skills to combat this encroaching threat. After five years of research on the area, she was ready to begin her journey writing about the Pine Barrens. Her first book, *Whispers in the Pines: The Secrets of Colliers Mills*, focuses on the rare plant and animal species that inhabit this area of the Pine Barrens. Through her writing, she became even more intrigued with the Pines and went on to author more titles on the subject, including this book. *Legendary Locals of the Pine Barrens of New Jersey* is the fourth book Karen wrote on the Pine Barrens subject and her fifth published in total. Many of the individuals in this book, too humble to even consider themselves "legends" in their own right, have all earned a special place among these pages through their passion for the Pine Barrens. Karen may have been a New York City transplant, but her years of hard work through writing and continued devotion for this area has earned a place of her own in this book of "legendary locals."

As Karen states in the acknowledgements, she was writing this book while fighting terminal cancer. Although she was often tired and experiencing much pain, she pushed through to finish the project only days before being admitted to the hospital for the last time. After fighting this second battle with cancer, Karen went home to be with the Lord on April 20, 2013. Karen has made a lasting impression on the Pine Barrens community through her efforts for Pinelands preservation, as well as the many relationships she has built with individuals along the way. May her legacy and love of the Pines live on through her writings. (Courtesy of photographer JD Thomas.)

CHAPTER SIX

Protecting Our Land

Fire ecology is what makes the area the "Pine Barrens" and not the "Oak Barrens." Necessary natural cycles of fire clear the forest of the oaks that crowd the sunlight from the young pines while melting the resin from the pinecones so that they can open and drop their seeds into the ground. The pitch pine, the Pinelands' predominant tree, has a heat-resistant bark that allows its sap to continue to flow and its tender needles to sprout within weeks of the blaze. Still, with encroaching development and fast-driven wind-spread fires, folks like Jeff Brower literally protect citizens' lives and homes from the threat of fire.

Others work to protect people from unnaturally occurring hazards, such as the 1987 threat from the Environmental Protection Agency to dump 15,000 drums of radium-contaminated soil in the Colliers Mills Wildlife Management Area, the northernmost jewel of the Pine Barrens. That is when folks are thankful for citizens like Cyndy Book and Gertrude Price, who spent months staying at the refuge to make sure that the toxic waste would never find its home—temporary or not—in the Pine Barrens. While they vigilantly wrote letters, physically blocked roads, and did what was necessary to save the land they cared about, politicians like Jackson mayor Dan Black sounded the battle cry and stood shoulder-to-shoulder to support the citizens.

Other battles go largely unnoticed, as they are waged in Pinelands Commission meetings and in courthouses. That is when citizens need folks like Pinelands Preservation Alliance director Carleton Montgomery and staff member Theresa Lettman to protect their rights and alert the public to impending action so people can make their government do the right thing.

On the other side are the early founders of the Pinelands Commission, including Candace McKee Ashmun and staffers Peter Yvilsaker and Rick Brown, who are all doing their best to do the right thing, with a brand new set of regulations, a freshly designed comprehensions management plan, and an act of legislature.

Within those new guidelines, Elizabeth Meirs Morgan sought to permanently protect and acquire land, using her knowledge and the network of people she had built up. Blanche Krubner, from her various organizations posts, also tried to protect and save land. Nan Hunter-Walnut was one of the early fighters, prior to the Pinelands Commission's inception, who banded citizens together to fight the jetport proposal. Sadly, Morgan and Walnut are no longer alive, but the results of their hard work remain.

As land gets permanently preserved, the tough work of deciding what to do with that acreage falls to various agencies like the Trust for Public Lands and the New Jersey Nature Conservancy. G. Russell Juelg, who works for the latter, is currently working on trail maintenance for the recently purchased Franklin Parker Preserve in Chatsworth, the former home of the DeMarco bogs, the area's largest cranberry operation. Just as the Pines go through seasons, so does land ownership, and determining its best and most appropriate usage is a big responsibility.

Jeff Brower

As early as second grade, Jeff Brower knew he wanted to work for the fire service like his relatives. Brower worked in Division B, the "hottest" division in the state, encompassing all of Mercer, Monmouth, Ocean, and Burlington Counties. Brower's section covered more than 100,000 acres. The Pine Barrens burn hotter and faster than anywhere else in the country. Out west, it can take three days to burn 10,000 acres; that amount of Pinelands forest can burn in three hours. Seen below is the Lacey Fire, Brower's worst. He never lost a man or a building during his lifelong career.

Brower says that a lot of people ask why he wanted to do this. He replies, "You are either going to love it or hate it—and if you hate it, you don't belong there." (Left, courtesy of photographer Andrew Gioulis; below, courtesy of private collection.)

Dr. Emile DeVito

Dr. Emile DeVito's older brother first got him interested in birds, which ultimately led him to getting a doctorate in ecology in 1988 for research on bird communities and vegetation landscapes in the Pine Barrens. DeVito has studied in forests all around the world. Since 1988, he has worked at the New Jersey Conservation Foundation (NJCF) as the manager of science and stewardship. In that role, he is responsible for developing management plans for their more than 20,000 acres of landholdings. DeVito is also a trustee for the New Jersey Natural Lands Trust and the Pinelands Preservation Alliance.

He views his role as learning what the latest research is and translating the scientists' language into terminology to which the bureaucrats have to listen. He hopes that "in addition to saving the land from development, we can save the Pine Barrens from being bled dry from civilization." (Courtesy of Dr. Emile DeVito.)

Dan Black and Cyndy Book

Dan Black was only 31 years old in 1987. After serving two years as a Jackson Township committeeman, he anticipated that the hardest thing he would have to do in his first term as mayor would be to marry people, but, on June 4, Sen. Leonard T. Connors told Black to drop what he was doing and come immediately to his office for a press conference. When he arrived, he was quickly briefed on the Environmental Protection Agency's plan to dispose of 15,000 drums of radium-contaminated soil in the Colliers Mills Wildlife Management Area.

The drums had been stored in northern New Jersey after the soil had been excavated from around and under homes in Glen Ridge, Montclair, and West Orange after being confirmed as radioactive in 1983. It had originally come from the Radium Luminous Materials Corporation, which had been extracting the chemical to make novelties such as glow-in-the-dark wristwatches. Colliers Mills, the northernmost part of the Pine Barrens, was supposed to be a "temporary location" until a permanent home could be found for the hazardous waste.

Opposition to the plan kicked off a battle that was waged for months at the management area, in political meetings, and through letters, and involved thousands of people, all the way up to Gov. Thomas Kean. While Black fought on the political battleground, a grassroots effort spearheaded in part by 24-year-old Cyndy Book (seen here with Black, reunited in 2009 for the first time since the 1987 battle) was being fought. Volunteers stayed overnight in their vehicles at Colliers Mills to prevent trucks with the waste from entering, organized phone chains, and set up a letter-writing campaign that provided donated letters, envelopes, and stamps to people stopping by to help—all people had to do was add a personal note.

Senator Connors said that he has never received so much mail over any one issue in his entire time in office and that the personalized letters, delivered in huge mailbags, really got his attention. It was estimated that more than 50,000 letters were sent. Book said she felt that two main reasons they won were because everyone stuck together, no matter what, and because of the thousands of letters that were written. She is not sure she would do everything the same way today, but she is proud of her role in saving the refuge. (Courtesy of photographer William Riley.)

Gertrude Price

Gertrude Price was one of thousands of volunteers who participated in protesting the dumping of radon in Colliers Mills. She recalls it as being a very exciting time to be involved in something so monumental, but she is still surprised by all of the interest after so many years.

It all started for her when her husband, Henry, came running into the house and told her to make as many sandwiches as possible, that they needed to get to the wildlife refuge. Gertrude quickly put together as many peanut butter and jelly sandwiches as she could until the bread ran out. She, her husband, and her sons headed down to the refuge that early June day and stayed to do whatever was needed until December, when it was confirmed that the radium was delivered to another state. (Both, courtesy of photographer Andrew Gioulis.)

Janet Jackson-Gould

Janet Jackson-Gould has liked every job she has had and feels that every job has been fun. She started her career at the Philadelphia Zoo. She was also then a secretary on the Pinelands Coalition, a group of citizens first organized to fight the jetport. After winning that battle, the coalition worked towards preservation. She has also served as president of the Medford Arts Center, president of the Medford Village Business Association, and executive director of the Woodford Cedar Run Wildlife Refuge.

Janet grew up riding horses, and, when her late husband, Bruce, took a job at Batsto Village, she began helping out with the horses. On Sundays, Bruce would drive the horses and Janet would sit in the back and give tours. She is also an active birder who was on the New Jersey Audubon Society's board for nearly 20 years; three of them as president. (Both, courtesy of Janet Jackson-Gould.)

Nan Hunter-Walnut
Nan Hunter-Walnut and her husband, Rick, spent more than 25 years fighting to protect and preserve the Pine Barrens. Nan was the cochair of the Pine Barrens Coalition, a grassroots effort of citizens to fight the jetport and protect the region. Rick was a founder of the Rancocas Creek Watershed Association, which fought to protect the water quality of the area.

In 1978, she was appointed by Gov. Brendan Byrne to serve as a member of the Pinelands Review Committee. Nan was a founding board member of the Pinelands Preservation Alliance and faithfully attended every meeting of the Pinelands Commission for many years. She was recognized for her dedication in 1991 and 1999. In 1994, the Association of New Jersey Environmental Commissioners honored her for her environmental work. (Courtesy of the Pinelands Preservation Alliance.)

Carleton Montgomery

Carleton Montgomery was seemingly on the fast track to an enviable career, living in Washington, DC, with his wife and young children. A partner in the litigation department of a large Wall Street firm, he faced challenging work for large clients. But at the end of the day, he felt it was not enough on which to build a life, especially with extensive traveling keeping him away from his family, and he began looking for something that could better meet his spiritual and emotional needs.

His parents had always been big on the outdoors and environmentalists at heart, and Montgomery recalled that his childhood expeditions with them were what got his juices flowing, so he began looking for an environmental job. At the same time, the Pinelands Preservation Alliance (PPA) was looking for a new director. While Montgomery is not licensed to practice law in New Jersey, his legal background has certainly been an asset. As Montgomery explains it, "The conservation effort is built into a set of laws so it is critical that advocates be able to work with those regulations, understand

how to apply those regulations, and how to improve them, if you are going to be effective."

PPA was nine years old when Montgomery took the reins, and one of his first tasks with the nonprofit was to increase memberships and donations so it could continue to pay staff who would regularly attend meetings and be the watchdogs and ongoing advocates they needed to be. Many volunteer organizations that preceded PPA cited this important point, because they experienced burnout and the inability of always having enough volunteers to cover where necessary.

One of the greatest challenges that PPA faces is to get the public to focus on and demand that politicians, who often pay lip service to protecting natural resources but actually work to defeat or weaken environmental protections, do the right thing by the Pinelands.

The most fundamental lesson that Montgomery has learned from 15 years at PPA is that, no matter how hard staff works, in the end, all they can be is servants to the public, helping them voice their love for the Pinelands or other natural resources for which they have concern. It is the politicians who control these decisions, and they are responsive to their constituents. The PPA always has to remind itself that good arguments only get people so far in this world. "In the end," Montgomery says, "you need good arguments backed by public opinion because that's where power lies." (Courtesy of photographer Andrew Gioulis.)

Theresa Lettman

When Theresa Lettman needed a drink of water back in 1987, she turned on the tap like everyone else and did not think about where it came from. When people in her Pine Lake Park neighborhood started talking about well-water contamination and aquifers, she did not know what they were talking about, but, because she worked for the Ocean County Library, she had the resources to find out. Over the next two years, she attended every Manchester Township meeting she could. This was during the time that Hovnanian Enterprises proposed building 17,000 homes, two strip malls, and a heliport in the 8,000-acre Heritage Minerals tract, only part of which was in the Pinelands Protection and Forest Areas.

Lettman soon learned of a new group being formed, the Pinelands Preservation Alliance, to be the watchdog for the Pines. When a job opened with the group, she applied. Today, she still attends meetings and helps others understand how to protect this area. (Courtesy of photographer Andrew Gioulis.)

Peter Ylvisaker

Peter Ylvisaker was expected to follow in his father's footsteps and enter government work. But he was offered a job by the farmer for whom he worked and did not want to go to college. His father won out, however, and Ylvisaker graduated from the University of Hawaii with a degree in political science, followed by a master's degree from Rutgers in geography upon his return home to New Jersey. He looks back now and knows it was the right decision.

He took numerous courses in planning and landed a job with the six-month-old Pinelands Commission. He recalls that it was an exciting time, although it was hard work developing the Comprehensive Management Plan and mapping out the areas in the newly minted Pinelands National Reserve.

In the early years, he recalls working seven days a week and once staying at the commission office until 2:30 a.m. working on maps so that if someone approached him with an application, he could advise the person whether it made sense or not—if the area he or she were considering was a growth area or a preservation area.

He recalls the commissioners and staff were "a good group of people trying to do their best to do the right thing and having to deal with the pains of people, some of whom obviously got badly hurt from the standpoint of buying a piece of property, thinking it was their 401K and along comes these regulations." Hardship waivers were applied to appropriate cases like that.

Ylvisaker admits that he left work more than once not feeling so good, but that by the next morning, he had sorted everything out by putting it in the context of the overall objective.

The majority of appealed cases had their original decisions upheld. Years later, Ylvisaker spoke with a judge who told him that he completed his work in a very professional manner with objectivity and balance.

Ylvisaker looks back at his six years as a principal planner with the Pinelands Commission and says, "I felt like we did what we were asked to do with a balanced view and I don't think anyone could ask for more. I wish everyone could have the opportunity and experience that we had." (Courtesy of photographer Andrew Gioulis.)

Rick Brown

Rick Brown attended Richard Stockton College in the 1970s, when students could structure their own classes. In retrospect, the courses he studied turned out to benefit him well in his first job after graduation, working for the Pinelands Commission's regulatory division. Like for coworker Peter Ylvisaker, it was an exciting time for him, full of groundbreaking decisions. Those courses—on soils, planning, interacting with people, and the psychology of working with them—served Brown well in his early years.

As Brown recalls, he was fortunate to get a job with the Pinelands Commission right out of college, and it helped him grow up fast. Some of the folks he encountered were very nice and others were angry; but, at their cores, people are passionate about their money and their land, and the Pinelands Commission was affecting both. The Comprehensive Management Plan then being developed affected their investments and what they could do with their properties and touched upon deeply held feelings.

Brown learned to listen better and learn what peoples' interests were, but he also discovered that among the older folks, there were generally two types of people—those that were well adjusted and those that were bitter. Brown swore that as he got older, he would not be one of the bitter ones, whom he realized had a lot of regrets. This has guided his attitude and his dealings with people, and one of the things he is most proud of is that he has no regrets.

Brown considers himself an optimist who believes in the power of big ideas, such as former governor Brendan Byrne's vision to declare a building moratorium to save the Pinelands after reading John McPhee's book *The Pine Barrens*. Brown has spent his career explaining and working to enforce regulations for the Pinelands Commission, and then protecting it and working with municipalities on implementation in his role as a land use planner for the Environmental Protection Agency.

He feels that the greatest threat to the Pinelands today is people taking it for granted. He points to the phenomena that if people drive past a piece of land every day and it stays the same, they do not notice it until change occurs, but at the point when bulldozers show up, it is too late. Just because the region is protected by regulations, people still need to appreciate it, because, until the land is actually preserved, it is still possible that it could one day be developed. (Courtesy of photographer Andrew Gioulis.)

Robert T. Zappalorti

Since catching his first frog at the age of six, Robert T. Zappalorti has had a passion for reptiles. He started his career in herpetology at the Staten Island Zoological Society, first as a reptile keeper and then as an associate curator.

While undertaking an extensive study on the bog turtle, he sensed a need for reptile and amphibian consultants, so he started Herpetological Associates in 1977. Pete McLain, then the deputy director of Fish and Game, became his first client. Since that time, Zappalorti has conducted wildlife inventories, served as an expert witness in courthouses and before numerous township planning boards, and had his photographs published in *National Geographic*.

He is most proud of training students and colleagues to carry on the work he has begun so more wildlife and habitat can be saved. (Both, courtesy of Robert Zappalorti.)

G. Russell Juelg

G. Russell Juelg is deeply grateful to a lot of people who patiently worked with him to help him understand how to be a naturalist and an advocate for the Pine Barrens. One of the dozens of folks on his list is Jeanne Woodford. She gave Russell his first conservation job at Woodford Cedar Run Wildlife Refuge after he arrived in New Jersey about 20 years ago. Originally from Texas, Russell graduated from Texas Christian University with a bachelor's degree in religion studies and felt he had a responsibility to be part of a team providing environmental education to protect the Pine Barrens.

Woodford ultimately made him part of the management team, and he became the managing director of the refuge in 1996. Along the way, he led field trips, managed educational programs, and brought in speakers like Howard Boyd. Cedar Run's founder, Betty Woodford, Jeanne's mother, had taught adult education classes at Lenape High School, so Russell revived some of the old programs, incorporating Betty's slides (she was a wildlife photographer). Jeanne also encouraged Russell to do outdoor programs like canoe trips, wilderness survival courses, and planned navigation courses with maps and compasses. Another program he developed was the Jersey Devil Hunt. When he began working for the Pinelands Preservation Alliance (PPA) in 1999, he brought his repertoire with him.

The Jersey Devil Hunt, through Wharton State Forest, proved quite popular. Russell would open with his banjo around the campfire, telling stories about how he arrived in New Jersey or something else more generic. As the smores were eaten and the embers began to die down, he would launch into tales of how the Jersey Devil came to wander these woods, and then the group would go on a hike to try to find him.

One of his first tasks upon arriving at PPA was to produce a booklet on threatened and endangered species so the public could recognize them, learn why it was important to protect their habitats, and find out how they could play a role in their local areas.

Today, Russell works for the New Jersey Conservation Foundation, maintaining trails on the recently acquired Franklin Parker Preserve in Chatsworth. He is most gratified when people turn out for field trips, get boots on the ground to explore, and spend whole days learning about botany or wild animals. (Courtesy of photographer Andrew Gioulis.)

Candace "Candy" McKee Ashmun

Candace Ashmun attributes her start in conservation to growing up in Oregon. After moving to Somerset County, in northern New Jersey, she quickly became involved in the fight to keep the jetport out of the Great Swamp. It was then suggested that it be located in the Pygmy Plains area of the Pine Barrens, so Ashmun and others from the watershed movement boarded a bus and spent a day viewing and learning about the Pine Barrens.

She became the first executive director of the Association of New Jersey Environmental Commissioners and secured an Environmental Protection Agency grant to teach land use and conservation methods. When the legislature passed a law to protect the Pine Barrens, the state was required to set up a planning entity, which became the Pinelands Commission. She was selected by the governor because she knew land use language.

Ashmun feels that what is so interesting about the Pinelands statute is that it is so well written. "It is one of the best written laws you could possibly have and then we ended up with such a good group of people for this thing, and the pattern is set by the initial people and then it's up the subsequent governors." Ashmun credits Terry Moore, the first executive director of the Pinelands Commission, for setting the tone. As she says, he stressed the idea that "we're going to be one group of people working together to carry out a mission."

Moore hired a number of people just out of school who had loyalty to the mission and "the combination of the leadership that Terry gave them to start with, Charlie Seaman who wrote the plan and Don Rogers from Pennsylvania who did the inventory so we knew what we were planning about—it just made all the difference. [They were] a bunch of people who were going to do this one way or another and find the best way and they did and that's why the plan, in my view, is pretty much the same as when we wrote it."

Ashmun stresses that she has no vested interest in the Pinelands, as she does not own land there, and that living in Somerset County allows her an outside, objective point of view. Her biggest concerns at this point are that "you can only regulate for so long" and that, in order to preserve land, it will all have to be purchased at some point—as well as global climate change. "We have to save the Pines or we are going to be very dry," she says. (Courtesy of the New Jersey Conservation Foundation.)

Blanche Krubner

A trip to Redwood National Park in California in the 1950s was a turning point for Jackson resident Blanche Krubner. She and her late husband, Ralph, fell under the spell of the redwoods and joined the Save the Redwoods League to protect them from logging threats.

When they returned to New Jersey, there was a fight in the north to save the Great Swamp from becoming the site of an airport, and, while Krubner did not get too personally involved, it drew her curiosity. She enrolled in some environmental courses around the time that Six Flags proposed to build its Great Adventure theme park in Jackson, bringing the issue to her backyard.

While at a municipal council meeting, Krubner heard the mayor say that the environmental commission was looking for members. In 1973, she was appointed to the commission, which she served on for 18 straight years, chairing the group five times. Krubner created a recycling program before there were laws about recycling, and she was the commission's liaison to the planning board for seven years. She also served as an Association of New Jersey Environmental Commissioners vice president.

Krubner graduated from Hunter College with honors and a bachelor's degree in economics, which she followed with a master's degree in history with a minor in geography from Trenton State College. Later, she earned a doctorate in urban geography with a minor in environment.

She put her education to work as an elementary school teacher in Jackson for 10 years and then as a high school teacher from 1975 to 1994, teaching economics, land use, environmental studies, and American and world history courses. This career also afforded her family the chance to take a vacation every summer and travel to almost all of the Lower 48 states in a trailer that slept all six members of the family. Ralph was a professional photographer.

From 1987 to 1992, Krubner hosted a Jackson cable talk show that she produced, selecting her guests and interviewing them. Krubner has also worn several more hats, including as an outreach technical specialist with the Environmental Protection Agency, as an editor for *Academic American Encyclopedia*, as a member of the Ocean County Environmental Agency and the Ocean County League of Women Voters, and as a trustee of the Pinelands Preservation Alliance board of directors. (Courtesy of photographer Andrew Gioulis.)

Elizabeth Meirs Morgan

Elizabeth Meirs was nicknamed the "Pioneer Woman" while at Bryn Mawr College in the 1930s. Later, she became known throughout the Pines as the "Pine Baroness." It was an fitting title, as Morgan helped to saved countless acres of land for permanent preservation.

New Egypt, the geographical center of New Jersey, was Morgan's birthplace. She once described it as "a place you wouldn't believe, like the back of beyond. There are no houses and sand roads, some that are passable and some that aren't." Her favorite spot was the stone hills on the coastal divide, a rocky elevated formation that divides the headwaters of the Pine Barrens. Water on the eastern side of the divide flows out to the Atlantic Ocean, while water on the western side flows into the Delaware River. In the spring, the divide is covered with mountain laurel, and she loved to take people there.

Morgan's aunts owned a 311-acre farm and they would show her all kinds of botanical treasures. She was late on the first day of kindergarten because she stopped to watch butterflies in the schoolyard. She got her love of history from her father and graduated with bachelor's and master's degrees in history from Bryn Mawr, although she said her favorite subject was geology.

She enjoyed talking to people and recording their stories of history and lore in her mind, and when land was threatened, she knew the key people to contact. Her efforts helped save the Lighthouse Camp for the Blind property in Waretown and Wells Mills County Park, which dedicated the observation tower, on which she is seen here, to her. For her efforts, Morgan received two GAEA Awards, the New Jersey Audubon Society Environmental Education Award, the 1995 Historian of the Year Award from the League of New Jersey Historical Societies, and the Encore Award from the South Jersey Cultural Alliance.

Meirs married Rev. Luman J. Morgan in 1941 and was active in the Christ Episcopal Church, Toms River, writing two books on the church's history. She was also a social worker and taught for three years at the Ogontz School for Girls. She was a founding member of the Forked River Mountain Coalition and helped save some of the land for preservation. She died in Forked River at the age of 90 in 2004. She will always be best remembered with her walking stick and her dogs in her Jeep, ready to discover another sugar sand trail. (Courtesy of private collection.)

CHAPTER SEVEN

Digging Up and
Preserving Our History

Before a legacy can be passed down to future generations, the current generation must understand and appreciate its past. Archaeologists like Dick Regensburg, Jack Cresson, and Budd Wilson have uncovered ruins that helped the public learn about the Batsto glass factory, the Bethlehem Loading Company's munitions plant and the surrounding planned community, Martha's furnace, and many other remnants of lost towns and native camps. It is their knowledge of the past that helps to determine if valuable artifacts or crucial pieces of history could potentially be disturbed by current road and construction projects

Scientists like Mark Demitroff and Dr. Eugene Vivian help people learn about the ecological history of this amazing region, which is also crucial to the future. Dr. Vivian taught students about conservation long before it became a buzzword, while Demitroff has argued for the need to conserve local ponds called spungs, which provide important habitats for rare and endangered species.

Folks like Paul W. Schopp and Guy "Teegate" Thompson help teach about other crucial aspects of history. Schopp has studied local history, trains, industries, and all forms of transportation, not only to educate through books and presentations, but also to do groundbreaking work that has resulted in the preparation of over 200 cultural resource reports and eight successful National Register of Historic Places nominations. Thompson's specialty is locating old property survey stones, which help anchor history in a very real way through place and time.

After history is uncovered, it must be conveyed to the public in meaningful ways so that folks will want to take action to see that the region is forever preserved from development and not just protected by laws that can later be changed. That is where county historians like Tim Hart and historical society curators like Eleanor Ditton and Pat Martinelli are needed, tirelessly answering questions and creating interesting programs that draw people in to learn more about the past.

Michelle Washington Wilson has found an old method of passing down history to be the most effective for her, and she is attempting to bring storytelling back to New Jersey as a way to get new generations to listen in a highly engaged way.

To keep pace with today's technology, Cathy Antener and Ben Ruset host websites that engage audiences all around the world. Antener's Piney Power website serves as a clearinghouse of local businesses, areas of interest, and monthly contests, and also produces a newsletter to keep viewers engaged. Ruset's New Jersey Pine Barrens website contains in-depth articles and historical maps, but the main draw is a lively forum where participants trade information.

Lines on the Pines is an annual event started by Jim and Linda Stanton that just completed its eighth year. It brings together artisans of all kinds so the public can ask questions and purchase their wares.

As Pete Stemmer has always believed, history should not be boring. The folks in this chapter are combining old, proven methods of uncovering history with inventive new ways of recounting it. The desired result is that readers discover a rich culture, history, and ecology worthy of being permanently protected for future generations.

Budd Wilson

Budd Wilson first became interested in the Pine Barrens in ninth grade, when he "devoured" Henry Charlton Beck's book *Jersey Genesis*. He became a historical archaeologist and has excavated several sites in the Pine Barrens, including iron furnaces, a window-glass factory, a lime kiln, and a schoolhouse. In July 1968, Wilson and a group of fellow archaeologists began excavating the Martha furnace site. They spent

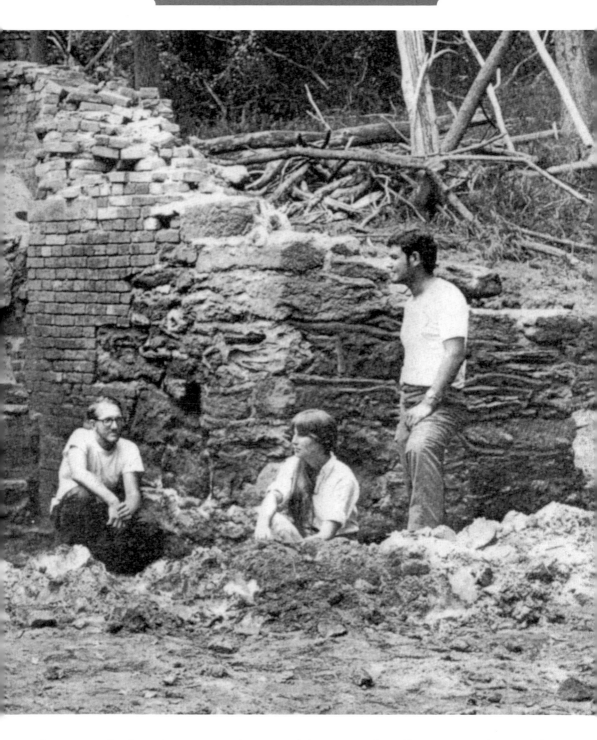

the next couple of months uncovering the ruins and documenting them. The ruins were then carefully covered to protect them from further damage from the elements and potential vandalism. (Courtesy of Jack Cresson.)

Dr. V. Eugene Vivian

Dr. Vivian was responsible for inspiring and inciting a love for the Pine Barrens in thousands of students and colleagues. Many name him as a mentor, and he was focused on conservation long before it became as popular as it is today.

He received his undergraduate degree in biology and chemistry from Montclair State University, his master's degree in botany from Columbia University, and his PhD from New York University with a dissertation on soils, forests, and grasslands conservation. He was named New Jersey Conservation Educator of the Year in 1967 and National Conservation Educator of the Year in 1968.

Dr. Vivian chaired the science department at Glassboro State College (now Rowan University) from 1955 to 1967. In 1966, he established a facility for training educators and students at Whitesbog called the Conservation and Environmental Studies Center, which he directed until 1984. (Courtesy of Terry O'Leary.)

Al Stokley

When Al Stokley was a boy, he received train sets and accessories as holiday gifts because that was all many boys wanted back then, in the days before video games and other technology. Although he worked at Fort Monmouth for his career, his passion for trains and the history behind them remained his hobby. In the early 1990s, he took his collection of old photographs, postcards, and railroad knowledge and started assembling them into presentations that he delivers at area colleges, historical societies, and community events.

"The Jersey Devil," a presentation on the Blue Comet line that ran through the Pine Barrens, remains his most popular talk. His audiences tend to be older folk, some of whom remember when the Blue Comet blazed through the Pines. They can identify with the information given in his talks, and some even have family members who worked on the line. Stokley points out that late freeholder James Mancini used to ride that line.

Most of his talks center on trains in the Monmouth and Ocean County areas, although he does touch on Middlesex County and occasionally Burlington County. He stresses that railroad traffic was quite diversified, including bringing soldiers into and out of Fort Dix for training, passenger service, excursions, and freight traffic—the railroads even operated special fisherman trains to bring people to the fishing boats. Stokley says that trains were so successful that it led to their demise, as people first came down for the weekend, but as they enjoyed what the places had to offer, they began moving here, helped by the new automobile.

One of his challenges is finding photographs, as people did not take many photographs back then. In the mid-1990s, Stokley counted 72 train stations still standing in Ocean County. Today, there are only a few, some having been converted to historical societies, like Stafford Township and Ocean Gate.

He made a small railcar himself (seen here) with a five-horsepower lawn mower engine that he occasionally rides with friends on abandoned track in the Pine Barrens. He would really like to see service come back to Lakehurst, especially since the emphasis today is on less pollution and because the track is still there. He feels that if people really want to save resources and trees instead of cutting down more trees, as was done recently along the New Jersey Turnpike and the Garden State Parkway, trains are the answer. (Courtesy of Al Stokley.)

Joan Berkey

Since her early roots as an English major and an advertising copywriter, Cape May resident Joan Berkey has come full circle. After purchasing an old house in 1975, she researched its origins, which led her to discover her passion for unraveling a building's history and took her back to college for a degree in historic preservation. She has now authored three books and freelances as a historic preservation consultant. One of her most rewarding projects was the Bishop-Irick House, which was purchased by the Pinelands Preservation Alliance for its headquarters.

Her work with archeologist Dick Regensburg led to the Bethlehem Loading Company site being added to the National and New Jersey Registers of Historic Places. The ruins of this former World War I munitions plant are now part of the Atlantic County Parks system. Its workers lived in nearby Belcoville, seen below. (Left, courtesy of Joan Berkey; below, courtesy of the Hagley Museum and Library.)

Richard Regensburg

Archaeologist Dick Regensburg lives in a house built around 1688 of Atlantic white cedar and other local materials. He is famous for his crab, shrimp, and dragonfly lures. He photographs living creatures and then duplicates the photograph using artificial materials like bubble wrap and upholstery stuffing, as well as genetically engineered chicken feathers, which are longer.

When Regensburg was a kid, his father took him to old Indian sites. It was just a hobby until he worked on the Savage Farm site in Marlton with Jack Cresson. Regensburg was responsible for getting the Pine Barrens boundary lines extended to include this site, based on his discoveries. He says, "I was trained by my dad to do everything perfect, everything right—scientific-like. Instead of sneaking on the farm and getting chased, we knocked on the door and they were so shaken up that they actually gave us permission." (Both, courtesy of photographer Andrew Gioulis.)

Mark Demitroff

Mark Demitroff is passionate about preserving Pine Barrens history and educating people about the region's unique landscape. He has been nicknamed "Spung Man" for his scientific work on local ponds called spungs, which are ground depressions scoured by strong winds during ancient cold periods. These intermittent ponds provide important habitats for rare and endangered species. Demitroff has long argued for their conservation.

After graduating from Rutgers University in 1982 with a bachelor's degree in agricultural science, he designed and built gardens and consulted as a certified tree expert. Planning a local nature trail system caused him to question older interpretations about ancient climate change. This attracted the interest of Dr. Hugh French, the dean of science at the University of Ottawa, alongside whom Demitroff worked for more than a decade to rewrite southern New Jersey's geologic history.

Pinelands folklore and folklife are also topics close to his heart, and he has done extensive research on people who settled in this area. While many focus on

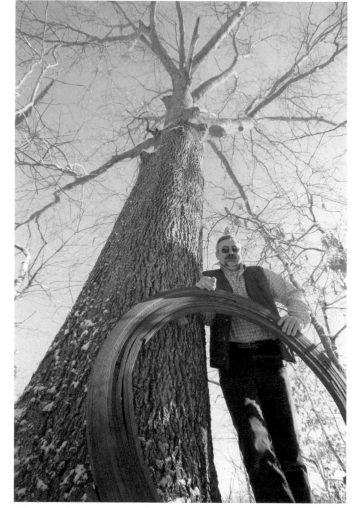

either historical, ecological, or cultural aspects of the area, Demitroff has managed to keep all three in the forefront through numerous lectures. He has also met with scientists throughout the world to discuss the scholarly value of the Pinelands geologic record.

Demitroff has worked alongside countless experts in various fields, including botanist and historian Ted Gordon, archaeologist Jack Cresson, and many others. Additionally, Demitroff is a member of the board of trustees of the Richard Stockton College of New Jersey's new Cultural and History Center and a board member of the US Permafrost Association.

Although he is a Pine Barrens native, Demitroff has remained close to his Ukrainian heritage, making several trips back to his ancestors' homeland to conduct studies to better understand the Pine Barrens' cultural and physical environment. In midlife, he has continued his education, earning a master's degree in geography (climatology) from the University of Delaware. He is currently pursuing his doctorate from the same institution with a specialty in land-surface processes.

Demitroff has been a tireless Pine Barrens public advocate, determined to insure that the Comprehensive Management Plan developed back in the late 1970s, when the Pinelands protection legislation was being put in place, remains the benchmark against which future applications are measured. In the past, he has taken the political battle to protect the integrity of Pinelands villages all the way to New Jersey's attorney general. (Photograph by Harry Benson, courtesy of Mark Demitroff.)

Jack Cresson

Indian artifacts have caught Jack Cresson's attention since childhood. While his aunts and uncles shared their interesting finds with him growing up, his initial aspirations in school were to become a fine artist. But in college, courses he took in archaeology, anthropology, and geology intrigued him enough to switch his major.

In the 1960s, the National Environmental Preservation Act and the Historical Preservation Act provided federal and state funding for a lot of archaeological work. Cresson did a lot of investigations along highways and roadways in southern New Jersey for both the state and the country, determining if there was archaeological value before projects could commence.

In 1963, Cresson began flint-knapping, the art of shaping stones through flaking techniques. He says it "started to enhance not only my appreciation but my way of interpreting archaeological data."

When a project occurs in the Pine Barrens, prospective builders have to abide by cultural resource regulations involving anything 50 years or older, regardless of whether the builder is an individual, a corporation, or the county, state, or federal government. Cresson has always been interested in the Pine Barrens because of its unique nature, the distribution patterns of humans, what they were doing out there, and the differences in resources between those who lived in the inner versus the outer coastal plains.

Cresson was inspired by Charlie Keir, who was the first archaeologist to look seriously at the Batsto and Mullica Rivers for evidence of prehistoric land use. However, it was not until 1978, when the federal and state governments passed preservation acts for the Pinelands, that any serious investigations were made.

Today, he does a lot of demonstrations and teaches at colleges and universities. His "primitive industries" workshops include introductions to flint-knapping, wood, which he calls "the ultimate precursor," cobbles, and meta-rocks. He teaches them in his historic home in Burlington County.

One of his favorite projects was the opportunity to work on the Batsto mansion. When prior owners rehabilitated the east wing, they dug tunnels from the core, which had little windows. He was able to find relics from all of the tunnel excavations, most of which predated 1760. What Cresson enjoys most about his chosen path is that "if you have a little more knowledge about where the stone came from and how it may have been shaped and what it may have come from, it opens up greater knowledge about the people that might have left that stone." (Courtesy of photographer Andrew Gioulis.)

Eleanor F. Ditton

Eleanor Ditton was born in Montclair but came to Lanoka Harbor when she was 13 years old. When her mother told her about the move, she could not wait to come. The house they moved into had no plumbing, heat, or indoor water. She remembers using the outhouse out back and peeking out to see if anyone was watching, even though it was pretty desolate back then. That first Thanksgiving, her father was without a job and she came home to find venison that had been donated by someone. "Where's the turkey?" she innocently asked, but her mother reminded her that she was lucky enough to have food, which ended the discussion.

Her favorite memories of growing up were walking through the woods and "swimming in beautiful cedar water which was ice cold, but refreshing." She loved being out in nature and walking through the undeveloped areas. Near the Lanoka Harbor School, there was a dug-out swamp with clumps of oak trees surrounding it, where she would ice-skate.

As a teenager, she would pick blueberries for 5¢ a pint, earning about $100 by the end of the summer. Ditton would take a bus up to Newark to buy her school clothes for the new semester with her earnings.

Barnegat Pines, a new development, began in 1926, but the Great Depression diminished the lot sales. The developer wanted the place to look more inhabited, so Ditton and her friends had the job of reclining along the lake as a bus of prospective buyers came by and then scrambling to the next lake to "populate it" before the bus got there. The buyers were then treated to dinner at the Greyhound Inn and one of the 20-foot-by-100-foot lots was raffled off.

After a brief stay in New Gretna, Eleanor, her husband, Paul, and their two children moved back to Lanoka Harbor. Some people think it is an Indian name, but it was actually coined by Sam Rogers to mean "Land of the Oaks"—he tacked "Harbor" on the end to draw fisherman. Stella Wilbert, Charlotte Lane, and Betty Grant lobbied to save the old Forked River one-room schoolhouse that Paul attended by proposing placing a historical society in the building that they would lease from the township for $1 per year with a 20-year lease. Eleanor became a charter member and has been with the historical society ever since, serving 10 years as president. (Courtesy of photographer William J. Riley.)

Paul W. Schopp
Raised by a railroading father, Paul W. Schopp held an early fascination with trains, while visits to historic sites like Batsto and Atsion stoked his interest in local and industrial history. These interests were rekindled when Paul became a professional historian in the cultural resource management field. In his work, Paul has prepared historical contexts for well over 200 reports. He has also written eight successful National Register of Historic Places nominations. Although he has worked in several states, he is most passionate about New Jersey history. Paul has written many articles and delivered numerous lectures, but in Pine Barren circles, he is best known for *The Trail of the Blue Comet: A History of the Jersey Central's New Jersey Southern Division* as well as the host of the annual Lines on the Pines event. Paul is a member of the West Jersey History Roundtable and is very much at home in his 14,000-volume private library. Despite all of his many accomplishments, he acknowledges that he would be nowhere without God and his friends. (Photograph by Cie Stroud, courtesy of Paul W. Schopp.)

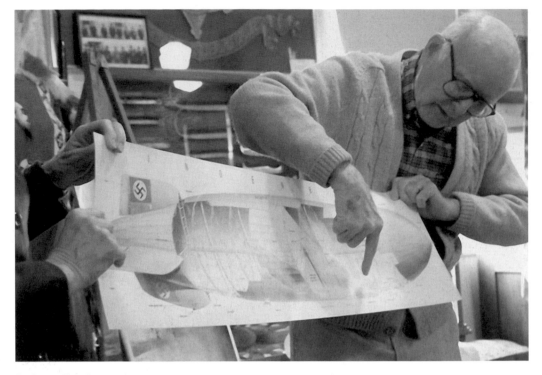

Robert Buchanan

Lakehurst Naval Base paid civilians to help with airships when they arrived, catching and securing the mooring lines. Bob Buchanan's cousin helped out, and Buchanan begged him to let him assist. It was an overcast day at Lakehurst when the *Hindenburg* began making its famous descent. There had been three heavy downpours, and Buchanan remembers that the sweater he was wearing was soaked. He was directly under engine one when, instead of dropping the mooring lines, the order was given to reverse, as hundreds of gallons of water were dumped, raising the tail of the dirigible.

He recalls looking up and seeing sparks and orange-red flames. There was no explosion. The grounds crew began to run and Buchanan's cousin had his hair singed. Buchanan feels that his wet clothing protected him from fire. Years later, his eyewitness account helped solve the mystery of what happened that day. Buchanan is believed to be the last ground survivor of the disaster. (Above, courtesy of Tuckerton Historical Society; below, courtesy of Pete Stemmer.)

Patricia A. Martinelli

Patt Martinelli is fortunate to have two dream jobs—one as the curator of the Vineland Historical and Antiquarian Society and the other as the author of 10 books, including true New Jersey crime anthologies and her first novel, which is part of a trilogy. She is best known for her book *Rain of Bullets*, an up-close-and-personal look at the mind of a psychopath written to dispel local legends surrounding a murder case.

After college, she took a job as a newspaper reporter, working her way from features to hard news at a time when women were typically assigned fluff stories. After a number of years, it grew too intense, and she returned to museum work, utilizing her master's degree in American history.

George Daynor is seen in the inset image at the Palace of Depression, a Vineland oddity and the subject of one of Martinelli's books. (Above, courtesy of photographer Andrew Gioulis; inset, courtesy of the Cumberland County Historical Society.)

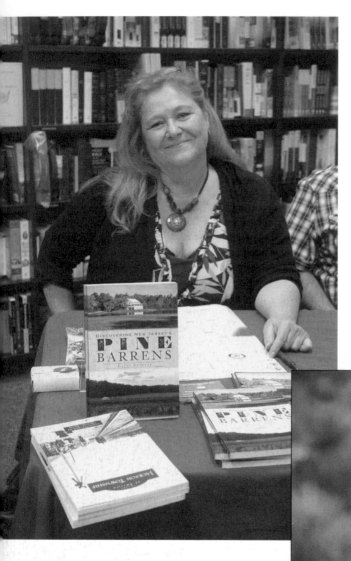

Cathy Antener
Cathy Antener combined her love of the outdoors with her passion for technology to create the website PineyPower.com in 1996. She worked for 20 years in Ocean County government, spending the majority of that time with the Department of Parks and Recreation.

Antener leads bus tours through the Pine Barrens, writes a monthly newsletter, and recently published her first book, *Discovering New Jersey's Pine Barrens*. (Courtesy of photographer Karen F. Riley.)

Ben Ruset
Ben Ruset is currently celebrating the 10th anniversary of his website, NJPineBarrens. com. A 20-year veteran of the technology field, he designed the site to have an interactive forum for discussions as well as articles and other resources.

His maternal grandfather loved exploring the region in the 1920s and 1930s, so Ruset's mother bought him Henry Charlton Beck's books to familiarize Ruset with places she saw as a child. (Courtesy of photographer Andrew Gioulis.)

Guy "TeeGate" Thompson

Guy Thompson (left) is an example of how the NJPineBarrens forum unites people seeking parallel goals. A frequent contributor, his post about locating the stones for Hanover furnace brought him face-to-face with Tom Worrell (below), the great-great-great-great-great-grandson of Benjamin Jones, who owned the furnace and the property where the stones were found.

Thompson has been exploring the region since he was 16. Today, his daughter Jessica often accompanies him. His specialty is finding old property stones by acquiring surveys, old deeds, and using his intuition. To date, he has located and photographed over 1,000 stones. When locating stones using his GPS, Thompson often thinks about his "day job" as a machinist and how, years earlier, the components he made for a satellite might be the very parts enabling his search today. (Left, courtesy of Robert Moyer; below, courtesy of Guy Thompson.)

Michelle Washington Wilson

Michelle Wilson is on a mission to bring back the lost art of storytelling in New Jersey and help people learn through listening. Wilson explains that storytelling is very big in Appalachia and the South and is found throughout most of the country. In the African American tradition, storytelling was very important for keeping and passing down the oral history of the family through the generations. In each family, it was one person's job to keep track of stories.

She points out that everyone loves a good story, and her dramatic, innovative style is designed to get her audiences to pay attention to not just the words, but also the meanings behind them. For example, when someone pops a delicious blueberry in his or her mouth, does that person think about the migrant worker who picked those berries one at a time, working in the hot sun for four to six weeks, then packing up in a rickety vehicle to move on to the next farm? When out at a restaurant and casually tossing the green garnish to the side, does a person think about someone picking parsley in the rain so her kids can eat? Wilson hopes that her play, *Dusty Days Gone: The Story of the People Who Harvest the Crops*, will help people think about such things.

Wilson attended Monmouth University, where she studied speech, theater, and education, graduating with a bachelor's degree in speech communication education. She is a workshop facilitator with expertise in work readiness, family literacy, cooking classes, and parenting skills. She currently teaches at Atlantic Cape Community College. She is also a basket weaver and a gourmet chef, having also graduated from the Academy of Culinary Arts.

Wilson has been featured in the book *Small Towns, Black Lives* by Wendel White. Her own book, *Reaching with Spirit, Growing Through Grace*, contains stories and poems that she performs with the goals of educating, entertaining, and enlightening her audiences.

Hailing from Newtonville, a place she considers "pure bliss in the Pines," she has been fascinated since seventh grade with the art of storytelling and getting people to use their imaginations. Wilson wants to learn more and tell about the everyday lives of people who live in the Pines, and specifically her own ancestors' story: Why did they come here? Why did they stay? What difference did they make? (Courtesy of Michelle Washington Wilson.)

Peter H. Stemmer

Pete Stemmer believes that history comes alive through people. In school, history was never his favorite subject; he did not like memorizing boring facts and dates. That was until his freshmen year at Ryder University, where he went to pursue a business degree. Two pivotal things happened to change Stemmer's mind about his degree: he took an accounting class as part of the degree requirement and discovered it to be more challenging to him than history, and he had an interesting world history teacher who opened his mind up to the possibility that history did not have to be boring.

So he transferred in his sophomore year to Trenton State College, got a history degree, and began teaching history at the junior high school level in North Brunswick, where he met his wife, Jackie, a physical education teacher.

The couple relocated to Toms River, where Stemmer taught remedial reading after obtaining his master's degree. They eventually moved to the New Gretna section of Bass River. His next-door neighbor Murray Harris believed that enjoying the environment was paramount, and so he took Stemmer sailing, canoeing to pick huckleberries, and hiking to various places in the Pine Barrens.

When Carolyn Campbell of the Ocean County Historical Society decided to write a book on the area's history, she approached Harris and Stemmer, who were very interested in the project but had no photographs to supply. This started Stemmer on a quest to knock on doors and ask people if he could look through and borrow their photo albums for the purposes of building a historical collection. This was before scanners, so Stemmer would spend days photographing each picture and then returning the album to its owner. Stemmer says folks seemed genuinely pleased that someone was interested in what they did and their family, and was going to the trouble of saving it for the future.

To date, he has preserved over 18,000 photographs on his computer, catalogued by family name. He is also a trustee of the Tuckerton Historical Society, a speaker on local history, and the author of a blog about Bass River Township history with the tagline "History without the boring bits."

Stemmer firmly believes that "history is about people—who they were, what their culture was, what they aspired to be, how hard they worked, how they loved their families, and their faith. History should be about the people who inspire us." (Courtesy of photographer Andrew Gioulis.)

INDEX